BAY AREA
STAND-UP
COMEDY

BAY AREA STAND-UP COMEDY

A HUMOROUS HISTORY

NINA G & OJ PATTERSON

THE
History
PRESS

Published by The History Press
Charleston, SC
www.historypress.com

Front cover, top, left to right: Phyllis Diller. *Courtesy of San Francisco History Center/ San Francisco Public Library*; Michael D. Booker performing at Comedy Day at its height. *Courtesy of Michael D. Booker*; Purple Onion building in 1964. *Courtesy of San Francisco History Center/San Francisco Public Library*; Mort Sahl holding the *San Francisco News*. *Courtesy of San Francisco History Center/ San Francisco Public Library*; *bottom*: Golden Gate and Bay Bridges with the Transamerican building in the background. *Photo by Josh Denault*.

Back cover, top: Milt Abel and Larry "Bubbles" Brown in front of the Holy City Zoo. *Photo by and courtesy of James Owens*; *inset, top*: Poster to advertise the second annual Comedy Competition (1977) at the Intersection. Dana Carvey won with less than a year into comedy. *Nina G's collection*; *bottom*: Advertising poster for Kevin Meaney at the Holy City Zoo. *Courtesy of Jeannene Hansen*.

First published 2022

Manufactured in the United States

ISBN 9781467149884

Library of Congress Control Number: 2021950581

Notice: The information in this book is true and complete to the best of our knowledge. It is offered without guarantee on the part of the authors or The History Press. The authors and The History Press disclaim all liability in connection with the use of this book.

DEDICATIONS

From Nina G:

In my junior year at Alameda High School, I turned in "Badaboom: An Anthology of Comedy and Humor" for an English assignment. For the purposes of this book, I would like to borrow the same dedication I had for that:

"To all the future, present and past comedians because their art is a big part of my life."
—Nina G

From OJ:
For Mel; I love you.

Special dedication to Mom, Dad, Mr. D., Ken, Ortavius, Caleb, Damien, Joe, Jan, Ed, Jesse H., Jesse M., Rocio, Sahra and anyone else from the "before times" who came out to my bringers, open mics and showcases. Extra special acknowledgements to David Cairns and Kelly Anneken for saving my life with their love and support. Shout-out to the comedy folks as well. All of them.

CONTENTS

PREFACE

NINA G

My family introduced me to stand-up comedy when I was about four years old. It was the height of Steve Martin's fame as a stand-up comedian. I'm almost positive there is a picture of me as a small child with an arrow through my head out there somewhere. My parents did not censor what I watched or enforce much of a bedtime. As a result, I would stay up watching classic *Saturday Night Live* episodes that led to me naming a favorite stuffed animal "Gilda" as well as a sock puppet in second grade that I named "Edith Ann" after Lily Tomlin's character. Even though I learned that Santa Claus and the Easter Bunny were a farce when I was seven years old, I didn't learn that Father Guido Sarducci was not an ordained priest until I was at least ten.

Cable TV helped feed my early love of comedy. There, I was exposed to stand-up as well as multiple runs of movies like *The Jerk* and *Caddyshack*. After school, I would take an afternoon nap just so I could stay up to watch *The Tonight Show with Johnny Carson* and, more importantly, *Late Night with David Letterman*. In third grade, I was identified as having a learning disability. This was about the same time I started to stutter, and I despised almost every aspect of school (Catholic school in the 1980s!). Knowing this, my mom let me play hooky at least once a month for us to go to the movies. This is where I saw films like *Richard Pryor Live at the Sunset Strip* when I was nine.

Throughout my childhood, I found solace in stand-up. Part of that was finding a feeling of superiority over my peers for not knowing the comedians who appeared on *Letterman* the night before. As I approached middle school,

they started to identify with musicians, hanging pictures of their favorite bands in their lockers or in their bedrooms. Comedians were *my* rock stars. While other thirteen-year-old girls were writing fan letters to music groups like New Edition, I wrote fan letters to comedians like Emo Philips, who responded back with an autographed picture that still hangs in my kitchen.

I am lucky to be a fifth-generation San Francisco Bay Area native. I was raised in Alameda and San Leandro and was exposed to the San Francisco comedy scene early on. As I approached adolescence, the stand-up comedy boom was exploding, and I was on the sidelines watching it. After church on Sundays, my family would sit for hours at Ole's Waffle Shop in Alameda with my aunt and uncle. I was so bored! To occupy myself, I would study the Datebook section of the *San Francisco Chronicle*, examining the comedians and clubs that I hoped to attend one day. As we lived half a mile away from Tommy T's Comedy Club in San Leandro, my comedy fantasies had a focal point. I so wanted to attend shows and then go hang out with the comics afterward at the Lyon's in the same strip mall. I couldn't wait until I turned eighteen years old so I'd be able to go to Tommy T's, followed by turning twenty-one and attending shows at the legendary Holy City Zoo. Sadly, the Zoo literally closed on my twentieth birthday. I saw names of comedians performing at the Zoo who I saw on *Comedy Tonight* and later heard on the radio on *The Alex Bennett Show*. Larry "Bubbles" Brown, Will Durst, Warren Thomas, Paula Poundstone, Steven Pearl, Dan St. Paul, Ellen DeGeneres, Tom Ammiano, Marga Gomez, Whoopi Goldberg, Bobby Slayton and Al Clethen were all names and faces in the milieu of San Francisco comedy in the 1980s and I dreamed of the time that I could see them in person. However, as I got older, my comedy nerd tendencies morphed and mutated into career ambitions.

There were two distinct windows of entry I had into the Bay Area comedy scene. The first was a joke contest I won when I was eleven years old on a KGO radio show hosted by a woman who also played Ms. Nancy on *Romper Room*. I told a joke that I stole from a recent appearance of Pee Wee Herman on *Late Night with David Letterman*. The special guest judging the jokes was Will Durst. The prize was free tickets to the Other Cafe to see him. Durst awarded me first place, and I was so excited to go to my first comedy club experience! That night, my parents, as they often did, ran late. When we got to the club, parking was scarce. We could see the opening act performing in the window on the corner of Carl and Cole. My parents said we were not going to go in because they didn't want to be made fun of for coming in late. As we drove down Haight Street, I was in

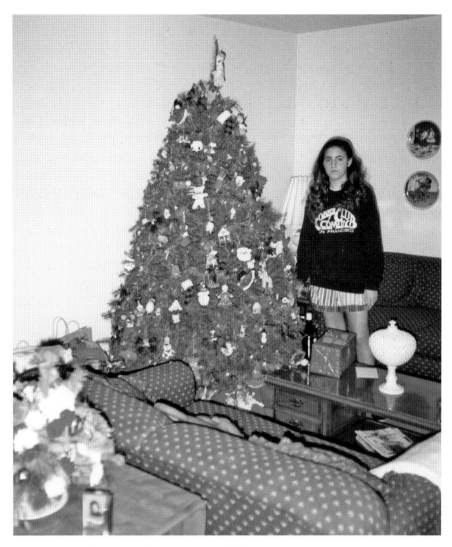

Picture of Nina G. *Photo by Nina's dad, courtesy of Nina's mom.*

tears because I would not be able to see the show. I would not get to the Other Cafe until I was fifteen—after I confessed my crush to Barry Sobel during his appearance on the *Alex Bennett Show* that same week. Previously, I had seen Sobel on Rodney Dangerfield's *Young Comedians Special*. Finally, I had someone I could focus my emerging hormones on. I happened to be sick that day from school and spent the day at my grandparents. Using their rotary phone, I eventually got through to the *Alex Bennett Show*. I

admitted on air that I would write Sobel's name on my notebooks and binders. He was very sweet when I met him. I still have his autograph from that night—it reads, "Keep writing my name on your notebooks."

My second entry came when I was around sixteen. As I entered my teen years, I started to write jokes and had a handwritten database of open mics that accepted minors. I would call venues and see if they allowed minors, which was immediately tracked in my notes. One night, I called Dorsey's Locker in Oakland, which would eventually and famously become comedian Luenell's Blue Candle Tuesdays. I asked if minors were allowed at their open mic, which I had seen listed in the *San Francisco Guardian*. The bartender yelled to the rest of the bar, cackling, "This bitch wants to be Eddie Murphy!" I hung up, scared! I was exposed. This bitch really did want to be Eddie Murphy!

Eventually, my dream to become a comedian died when I was seventeen years old. Being a person who stutters, I thought being a stand-up comedian was not in the cards for me. I went on to college, writing papers about comedy every chance I got, but besides going to an occasional show, my passions were only academic. In 2010, after a number of life-altering experiences, I returned to my dream and stepped on the stage for the first time. I had the choice of countless open mics across the Bay I could go to. I ventured to places like the Brainwash Cafe, where I was baptized into San Francisco comedy by Tony Sparks. I would find myself performing at the clubs I read about in the Datebook back at Ole's. I also had the honor of performing alongside many of the comedians I grew up watching. Stepping onto the same comedic scene that produced Mort Sahl, Phyllis Diller and Robin Williams felt like sacred ground.

After I had spent eleven years in comedy, the COVID-19 pandemic and subsequent quarantine of 2020 hit. Comedians were forced to retreat to Zoom shows if they wanted to perform. We also had a lot of free time on our hands. Where once we would be grinding it out at open mics and showcases, we had to find things to do with our time and creative energy. That is when I started a short-lived YouTube video program titled the *Comedy Time Capsule*, where I interviewed comedians about their experiences and predictions of comedy during the pandemic. It was after hearing Marga Gomez's experiences about the queer comedy scene at the Valencia Rose that an idea sparked.

Comedians don't always know their history, nor are they great about honoring it. I called my old comedy friend and fellow comedy nerd OJ Patterson, and the spark of an idea took flame. We would write a book that

broadly explores Bay Area comedy in words and pictures. Luckily, those late nights talking and doing comedy at McGrath's open mic in Alameda, followed by tea sessions at my Oakland apartment on nights that OJ couldn't BART back to the city, paid off.

I personally hope that this book reminds comedians of the Bay Area where they come from and the backs of the people they stand on while also celebrating our comedy history. I can already hear the critiques of comedians and comedy fans alike! "You didn't talk about (this person) or (that place)." Yep! You are right. There is a lot left out, which is probably why there has not been a comprehensive book written about Bay Area comedy. Each of these chapters could and should be a four-hundred-page book. I hope that subsequent books will come, but in the meantime, I hope you enjoy this edition about the history of San Francisco Bay Area comedy.

PREFACE

OJ PATTERSON

It's an honor to write this book. There's nothing like it, from what we could tell. Still, the fact I'm writing this book, the "first" book, in the year and context that I am, is a low-key disgrace. Sorry. That's a bit harsh. Let me walk that back.

There are certain things in pop culture, in life, so fundamental to me that learning about it late feels offensive. Hurtful. For instance, I didn't hear the Beatles until I was in my twenties. Since then, I've loved the Beatles. And I can't help but feel a twinge of sadness about my tragic time *without* the Beatles. Why didn't anybody tell me about "The Fool on the Hill" when I was a sensitive, mopey teenager, when I needed it most?

After graduating college, I was listless. Unemployed and unmotivated, I farted around with friends who were still in school. I lurked around UC Berkeley, wandering the campus, cosplaying as a student there. By complete happenstance, an encounter with a flier for the student improv group jericho! led to a show in a subterranean classroom, which led to another show at the Dark Room Theater, which led to, well, everything. Bay Area comedy, a world of inventive minds, lore and excitement, has defined my life since.

Performing stand-up comedy and writing about the scene was like grad school. My paradigm, my trajectory, completely changed. Ideals and ideas—largely pious-based moralism and virtue signaling—were constantly challenged. I thought I was so many things growing up. Doing comedy made me investigate those beliefs, prove them. Interacting with very real, very different, brilliant, bold and fearless people, in brief, passing, impactful

engagements, helped reveal the person I want to be and the person I really am. It was an education of growth and loss in every way imaginable. I found good friends, new heroes, my people, my language. I met my wife in the process. I owe a lot to my time telling jokes. Bay Area comedy is life. For a time, it was *my* life. Sometimes it still is.

So, learning about Bay Area comedy relatively late in life, as a young adult, feels like a betrayal. A low-key disgrace.

I'm a second-generation Bay Area person—my dad is from Missouri and my mom is from North Carolina. Born in Hayward, raised all over, I have a personal anecdote about every BART station. By the age of sixteen, I knew the pros and cons of every art house theater in the 925, the 510, the 415 (and how to get there on the bus). My coming of age was defined by an unlimited desire to know, learn, search and seek art, culture and novel experiences in "The City," "The Town" and beyond.

I'm a second-generation comedy fan—my dad loved Richard Pryor, and my mom loved Paul Mooney. Comedy was my connection to the outside world, how I learned about different cultures and understood the experiences of others. Half-hour specials on Friday were a constant. *Runteldat* and *The Original Kings of Comedy* were essential movie theater experiences. I made mixtape CDs with clips of television shows, recorded proto-podcasts with childhood friends, took road trips to television tapings and comedy clubs, wrote jokes in cafés with college classmates. Funny was everything.

If ever there was an adolescent who needed to know about the likes of Warren Thomas or that SF Sketchfest was happening nearby, it was me. In theory, I could have watched *Zach Galifianakis: Live at the Purple Onion*, the special that made me want to do stand-up, actually live at the Purple Onion. Why didn't somebody put "Bay Area" and "stand-up comedy" together for me, and let me know San Francisco was the place for that? Why didn't I look into Bay Area comedy, or *think* to look into it, for myself?

It's no one's "fault," really. Stand-up comedy often lives in the margins of society, a shadow dimension. It's opaque, sometimes intimidating. Most people won't know about the developing comedy talent in their hometowns until days, weeks and years later, if at all. And comedy that happened decades ago? Forget about it! You have to be a super comedy nerd to even look that stuff up. You had to be active in that era to have evidence of those long past laughs (or to know where to find it).

That's why Nina and I became friends. It's what led to this book. To find someone with a similar obsession about comedy, especially Bay Area comedy, is a rare and treasured connection.

One could argue that everything happened for a reason. The age I found SF comedy was without barriers or permission; comedy venues are largely limited for minors. Being an adult meant I didn't have to ask for permission. Comedy quickly became "my thing." And it was probably more impactful "how" I made it mine.

Never thought I could do stand-up until I saw it as an adult in my hometown. Never thought to research and write about it until after I started performing. As I dug, I kept finding out about *amazing*, seemingly obscure facts and connections to the people I met and places I performed. In a city full of transplants and trailblazers, natives and those passing through, a consistent, organic, undeniable tradition to foster great comedy has always persisted.

The timing of my induction was also advantageous. In addition to giving access to numerous newspapers and databases, the internet democratized people's ability to share their memories, their stories. A podcast here. A Facebook post there. An abandoned Myspace page with a trove of candid pictures. So many memoirs! Not enough biographies!

Bay Area comedy history is full of special artists who recognized their time, their era, was also special. Preserving that specificity is a scattered, personal, often thankless task. But their contributions, officially and unofficially, were invaluable to this book (and my life).

Hopefully, this won't be the only collection of San Francisco Bay Area comedy history published. That would be sad. We couldn't get to everything. I don't think one book can. Respectful apologies to all the sketch and improv fans and performers. The Committee, Spaghetti Jam, Femprov, Bindlestiff Studio, BATS Improv, Endgames Improv, Killing My Lobster, Culture Clash and so many others deserve more time and attention than we were able to give (this time). I hope there will be many books that celebrate all the uniquely talented, funny folk that the Bay has nurtured.

And not just books—I hope knowledge about Bay Area comedy takes every form imaginable. I hope there's a comedy museum in North Beach or Oakland one day, an Airstream trailer full of memorabilia to tour to local junior high and high schools. I hope that humor-loving people living in the Bay Area, or anyone who's interested in the "San Francisco Bay Area" and "stand-up comedy," find more answers than questions after reading this book. Or, at least, I hope they ask different, better questions about the art form, lifestyle and subculture; I hope they dig deeper. I hope people are encouraged to go to a show or to start doing comedy themselves. I hope this helps.

ACKNOWLEDGEMENTS

There are countless people who the authors owe a debt of gratitude toward. Both of us have found many friendships and mentors within the San Francisco comedy community, and those relationships informed and inspired us through this process. Also, thanks to the many photographers and archivists who assisted us through this process. Because of this help we were better able to make the history of our community come alive and honor it. Our thanks go out to Larry "Bubbles" Brown, Mean Dave, Debi Durst, Tony Sparks, Jeannene Hansen, Jim Owens, Barry Katzmann, DNA, Milt Abel, Carrie Snow, Dan St. Paul, Ngaio Bealum, Myles Weber, Jon Fox, Michael D. Booker, Rena Azevedo Kiehn, Niles Essanay Silent Film Museum, Lara Gabriel, Don Novello, Norman Hazzard, Kymberlie Ingalls, Patrick Ford, Lisa Geduldig, Tom Ammiano, Marga Gomez, Wonder Dave, Kristee Ono, Steven Pearl, Bob Aryes, Barbi Evers, Donald Lacy, Jack Tillamany, David Miller, Ritch Shydner, Greg Edwards, Kevin Camia, Mary Van Note, Jeff Zamaria, Sal Calanni, Elisa Leonelli, Isaac Felman (GLBT Historic Society Archives), Stuart Birnbaum, Abhay Nadkarni, Ethan Orloff, Shawn Robbins, Drea Meyers, Justin Gomes, Kathy and Jerry G and Dan Dion. Gratitude also to everyone who contributed to the GoFundMe campaign to assist in paying for the licensing of many pictures you will see in this book.

Special thanks to Laurie Krill from The History Press for accepting this project and answering all our questions, no matter how odd and disorganized. We appreciate your mentorship through this process.

1

BEFORE THERE WAS STAND-UP COMEDY

The Bay Area is rich with histories of many people and communities. The first of these begins with the Ohlone and Miwok people who lived throughout the San Francisco Bay Area. There were many Ohlone villages, including three located on what we now know as Oakland. As the first Europeans came, so did their missions occupying Native land (Dolores in San Francisco, San Rafael in the North Bay and San Jose in the East and South Bays). Spanish-Mexican rancheros like the Peralta family of the East Bay came to establish their lives and livelihoods. As United States citizens came across the country, they grabbed land from the rancheros whose missions had previously grabbed the land from the Native people. Americans would establish the cities that we know today. Yerba Buena Island became San Francisco, while land farther east that was once called Contra Costa soon became multiple cities, with the biggest being Oakland in 1852. Contra Costa translates from Spanish as "opposing coast" to denote the proximity to San Francisco. *Opposing coast* would be a social and cultural identity that cities like Oakland and Berkeley would one day grow into and embrace.

There are certain events that are closely associated with the history of the San Francisco Bay Area. These include the gold rush, the earthquakes (1906 and 1989), immigration, establishment of ethnic enclaves and the great migration of African Americans. All of these and more play a part in the cities where the stories and history within this book occurred. For example, the gold rush established San Francisco as an "anything goes" city where streets are named after the sex workers who occupied them. The underworld

that developed during Prohibition would one day turn into the legal bars and nightclubs where San Francisco comedy would flourish. The tolerance for the fringe would welcome beatniks, hippies and the "off-beat" comedians who were countlessly referenced in articles about Bay Area comedy starting from the 1950s to today.

Stand-up comedy is a uniquely American art form. According to comedian and comedy historian Ritch Shydner, Artemus Ward, who set out to humorously parody lectures that were popular in the 1850s (think funny but faux TED Talks), was the first stand-up comedian. As the first, he had the challenge of acclimating audiences to public laughter, which was taboo, especially for women. Ward was working on the East Coast when he received a telegram inviting him to perform at the Maguire Opera House in San Francisco. The theater was located at 618 Washington Street. The change of locations was welcomed because with the Civil War raging, many audiences in war-torn America didn't feel like laughing. The San Francisco audiences were receptive to Ward and the new art form. The price of admission was paid with gold nuggets. Ward performed around Northern California and Nevada. Shydner adds that Ward often performed for mining camps, alerting potential audiences nearby that there was a show

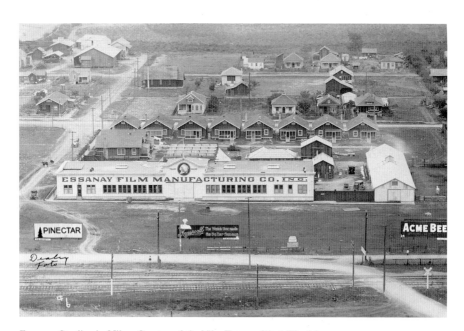

Essanay Studios in Niles. *Courtesy of the Niles Essanay Silent Film Museum.*

by a lighting a bonfire. Ward was friends with Mark Twain, who also made his stand-up comedy debut in San Francisco.

This book will broadly examine the 1950s to the present day in the San Francisco Bay Area. Although he did not fall in this period, it is important to acknowledge Charlie Chaplin's time in the Bay Area, as it mirrors some of the experiences of the comedians who would come after him. Charlie Chaplin filmed five one-to-two-reel shorts while working in Niles, a small town bordering the city of Fremont. Currently, Niles is part of Fremont. Although Chaplin was not a stand-up comedian, his universal influence on comedy is undeniable and thus important to include here due to his early comedic connection in the Bay.

The Essanay Film Manufacturing Company was based in Chicago but owned lots in Niles to make silent films. The two executives running the studio were George K. Spoor and Gilbert M. Anderson (popularly known as Bronco Billy, one of the first stars of Westerns), who phonetically merged their last name initials to come up with the company's name. The studio heads coaxed Chaplin away from Keystone Pictures with big money for Chaplin at this point in his career. These movies were shot in Niles as well as other locations across the Bay. According to Rena Azevedo Kiehn, the following movies and their locations included:

- *A Night Out* (1915)—shot in Niles (interiors), San Jose and Oakland (exteriors)
- *The Champion* (1915)—interiors and exteriors in Niles
- *In the Park* (1915)—North Lake, Golden Gate Park
- *A Jitney Elopement* (1915)—shot in Niles (interiors), San Francisco (exteriors)
- *The Tramp* (1915)—interiors and exteriors in Niles

Chaplin came to Essanay and Niles after he became a famous vaudevillian performer in his twenties. While in Niles, he was tolerated by his neighbors but not celebrated as he was elsewhere. He was reported pinching women's bottoms in the bleachers at the local baseball games. In spite of his weekly income of $1,250, he was known for being cheap, partially due to his "Dickensian existence reminiscent of Oliver Twist." Chaplin was "ambitious and a workaholic…trying to 'find the funny doesn't make you necessarily popular [off screen],'" according to Alzevedo Kiehn. She sets the scene: "Picture Chaplin walking around town practicing his schtick—can you imagine Jim Carrey early in his career if he was in some small town

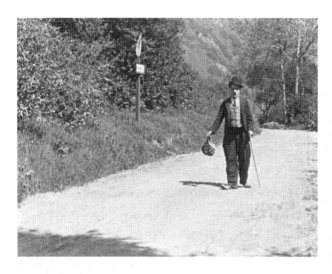

Final scene of *The Tramp*, filmed in Niles Canyon. *Courtesy of Niles Essany Silent Film Museum.*

working on his mannerisms and bits? It would be funny up to a point and then it would be obnoxious. Because to get it perfect would take practice. He could be hysterical on the screen for half an hour and then you go home to your normal life but what about if you see him not 'turning it off.'" Chaplin's behavior is not uncommon among comedians.

The Florence is a bar just a few blocks from where Essanay Studios was located. Today, the bar, popular with bikers, hosts a weekly open mic. Passing by, you can see comedians standing in front of the establishment, inserting their new bits into conversations with comedy peers or customers at the bar. If you wait around to see them perform at the open mic, you will see them repeat the same material while on stage. Chaplin's behavior might have been just as annoying as these comedians, but the practice paid off. According to Michiko Kakutani, "Chaplinitis swept the nation, spawning imitators, carbon strips and novelties like the Charlie Chaplin squirt ring. People danced the Charlie Chaplin glide, and sang about how 'ev'rybody does that Charlie Chaplin walk.'" It was the same year, 1915, when his movies filmed in the Bay premiered, with *The Tramp* becoming his most recognizable character. The iconic final scene shows Chaplin's character walking down a dirt road in Niles Canyon.

Like many comedians who would come after him, Chaplin's next stop after the Bay Area was Los Angeles. Eventually, the Essanay Studios moved completely out of Niles as well. Other studios were coaxed by townspeople to Niles. The proximity of the train almost across the street was ideal, not to mention the Bay Area weather. Eventually, all the studios went the way of Essanay and moved out of Niles. According to Azevedo Kiehn, the reason

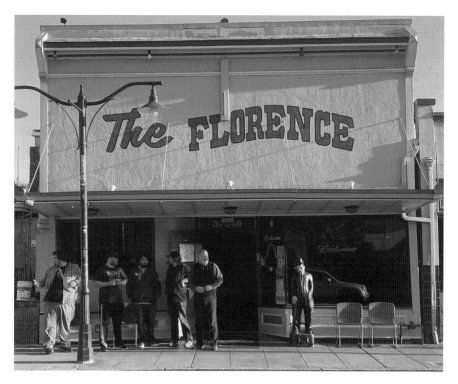

Comedians hanging out in front of the Florence on Jeff Morris's open mic night in Niles, the street that Chaplin once worked. Note the Chaplin statue in front. *Photo by Nina G.*

was talkies. With the advent of sound, having a studio across from a rail station with multiple trains coming through each day offered problems to the new industry. Not to mention, the more arid environment in Los Angeles was more conducive to filming, being uninterrupted by a rainy season.

Nonetheless, Essanay Studios and Chaplin are still celebrated in the Niles District. Stores, bars and restaurants on Niles Boulevard have signs and statues of Chaplin's Tramp character. Every year since 1979, the Niles District has honored its famed star with a yearly festival in June. In recent years, it has even included a group walk down the same street that is featured in the final scene of *The Tramp*.

2

THE COMEDY OF SAN FRANCISCO'S NORTH BEACH

The streets of San Francisco's North Beach area bustled with jazz clubs and coffeehouses in the mid-1950s. The mostly Italian neighborhood bordered on the oldest Chinatown in North America. North Beach became the backdrop to a new bohemian movement that was taking root. It is where the Beat poets of the time assembled at cafés and bars like the Co-Existence Bagel Shop. Other than one bagel that hung as a decoration, there were no bagels to be seen or eaten. The café front at 1398 Grant Street served beer and cappuccinos to the group of men who would soon be called the Beat poets. In April 1958, Herb Caen, the iconic columnist of the *San Francisco Chronicle*, coined the term *Beatnick* to describe the occupants of North Beach who donned black clothes and berets, attended poetry readings and occupied coffeehouses.

On North Beach's Broadway, there was a mix of jazz clubs, topless bars, topless bars with jazz and jazz clubs with topless performances. Carol Doda, the world's first public topless dancer, go-go danced on a piano at the Condor Club on the corner of Columbus and Broadway and would later appear performing in fashion designer Rudi Gernreich's topless swimsuit in 1964. Doda's fame grew like her saline-induced bust size, eventually putting her not only on the marquee but also in neon glory complete with two red lights that beamed from her nipples (which were concealed, of course). In 1965, she was charged with indecency. This would be one of many legal cases that emerged from the three-block radius that

included City Light's publishing of *Howl* and Lenny Bruce's act at the Jazz Workshop. Today, the Condor Club stills stands with a historical landmark plaque that reads:

The Condor Club
Where It All Began
The birthplace of the world's first topless & bottomless entertainment
Topless—June 19, 1964
Bottomless—September 3, 1969
Starring Ms. Carol Doda
San Francisco, California

Walking down Broadway toward the Bay Bridge, one would encounter clubs like the Jazz Workshop and Ann's 440. Ann's 440 was a legendary nightclub in its own right and originally operated as Mona's 440. Mona Sargent opened her bar in 1934, shortly after Prohibition ended. The original spot was on Union Street, but she soon moved her establishment to 140 Columbus at the bottom of the steep sixteen-step basement where the Purple Onion would later open. Sargent intended to open a bar serving the bohemian set, attracting artists and writers. With a lesbian presence in North Beach, it quickly became a lesbian hangout. It is considered the first of its kind to grace San Francisco, so much so that other establishments would soon open, like Tommy's Joint (note to locals: this is not affiliated with the famous Hofbrau on Geary) and Chi Chi. Sargent eventually moved her bar up the hill to 440 Broadway.

At Mona's 440 is where the bar and the early lesbian and transgender scene flourished. Mona, although straight herself, created a safe environment for her gay but mostly lesbian patronage. She fought with the police against raids and made sure that the clientele were treated with respect. This was especially important because San Francisco sexual tourism was a popular attraction. Tour buses would come through to see the female impersonators at Finnochio's as well as the "male impersonators" like Gladys Bentley at Mona's. The waitstaff wore tuxedoes and had short haircuts, rejecting the feminine norms of the time when the bar was at its height of popularity. It is unclear if the performers and staff were truly impersonating men or simply living without gender conformity and expressing themselves. The attraction of a place where "girls will be boys" helped the bar sustain itself by normalizing lesbian culture and gender fluidity. Mona eventually left the bar, and it became Ann's 440. Ann's did not hold tight to the tradition

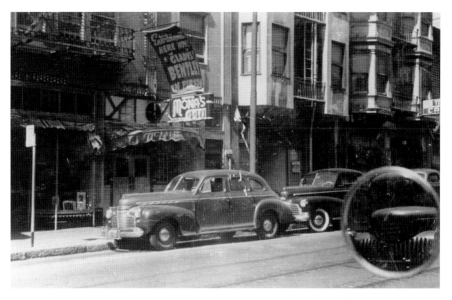

Exterior of Mona's 440 on Broadway in San Francisco. *Courtesy of Gay, Lesbian, Bisexual, Transgender Historical Society, Wide Open Town Collection.*

of all-female and transgendered entertainment, but it is said to have remained LGBT friendly.

If you crossed Columbus, going toward the Broadway tunnel, you would find the Committee, a small theater dedicated to improvisational and sketch comedy.

From the Condor Club, you would cross Broadway walking downtown, passing City Lights Bookstore and Vesuvio, where Francis Ford Coppola wrote the screenplay for *The Godfather*. About a block down the street, you would also find the Purple Onion and the hungry i (the name purposefully lowercased for disputed unconfirmed reasons) in the same direction. Folk groups like the Kingston Trio were staples at the Purple Onion, but when they wanted to record their live album, it was the brick wall background of the hungry i that they chose. In fact, San Francisco can claim to be the original brick wall that would later be universally associated with stand-up comedy, but some in New York might argue the claim. Many of the owners of local clubs were almost as colorful as the acts they invited and promoted at their clubs. The owner of the hungry i, Enrico Banducci, was a fixture for decades in North Beach. When Bud Steinhoff approached Banducci about the proposed name for his new club, the Song Cellar, Banducci mocked him and said, "That's an awful name...anything would

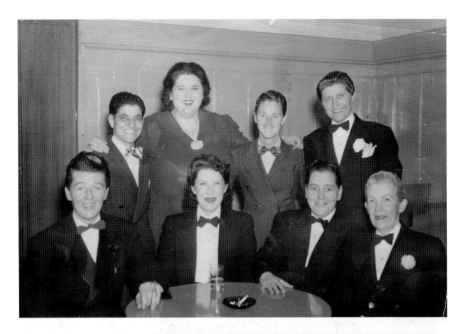

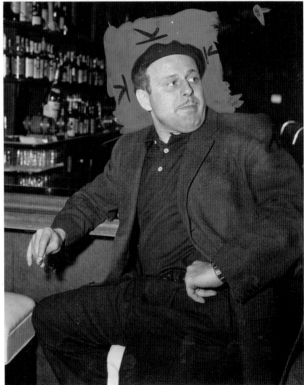

Above: The staff at Mona's 440. *Courtesy of Gay, Lesbian, Bisexual, Transgender Historical Society, Wide Open Town Collection.*

Right: Enrico Banducci, proprietor of the hungry i in 1958. *Courtesy of San Francisco History Center/San Francisco Public Library.*

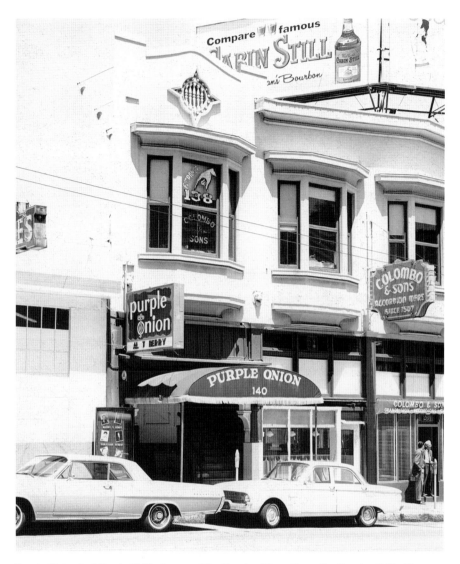

Purple Onion building in 1964. *Courtesy of San Francisco History Center/San Francisco Public Library.*

be better—even the Purple Onion." And from there the club's name remained for decades to come.

The lively neighborhood of North Beach, pulsating with jazz, folk and poetry, was the setting for a new form of stand-up comedy that would emerge in the mid- to late 1950s. At the time, the only stand-up comedy around was seen on mainstream television shows like *Ed Sullivan*. There

were also the resort nightclub comedians in the Borscht belt of the Catskill Mountains that were closely associated with stand-up comedy of the 1950s. The comedians delivered one-liners about subjects like mothers-in-law, often not written by the performers themselves but taken from published joke books. Much like the Beat poets, the humorous material of these new stand-up comedians reflected nonconformity and realism that would eventually result in censorship, obscenity charges and court trials. In the mid- to late fifties, some comedians who would later become famous performed in the nightclubs of North Beach, such as Phyllis Diller, the Smothers Brothers, Mort Sahl and the infamous Lenny Bruce.

From the stages of clubs like the hungry i, modern stand-up comedy was cultivated. It evolved from the "take my wife, please" one-liners to something more insightful, that cut deeper, with further elaboration like, "And here's a list of reasons *why* you should take my wife." It challenged the formula of stand-up comedy at the time with the move away from standard set-up/punchline formats. It allowed comedians to meander, at times weaving personal insights and political challenges, to a laugh. Much like the improvisational jazz that surrounded many of the comedians in the clubs where they performed, the comedians explored the capacities of a comedy routine. They deconstructed the structures and the content of their twenty-to-forty-minute sets, eventually changing the approach for the entire medium. And as with all things related to change, breaking new ground had its consequences.

PHYLLIS DILLER

In 1945, Phyllis Diller found herself in a housing project in Alameda. The Lima, Ohio native came with her husband, Sherwood, son Peter and daughter Sally. Sherwood secured a job at the Naval Air Station, but it quickly came to an end, putting the young family in financial crisis. Diller, as she tells it in her biography, had to go to work to help support the family. This led her to numerous jobs at newspapers, radio stations and in advertising. Diller, a devout atheist, also became an active member of the First Presbyterian Church on Santa Clara Avenue in Alameda, where she was the music director. Using her training from Chicago's Sherwood Music Conservatory, she became known as musical and funny. Always being the "life of the party," she was asked to provide musical comedy at parties around Alameda. One of her first paid gigs was at the Naval Air Station for a holiday party.

She was paid with a live turkey that she walked home on a string leash. It being late, she tied the turkey up outside, only to be woken up by her neighbors, who figured a turkey on a leash had to belong to Diller and her family. The neighbors offered to butcher the bird if they could have half of it. Diller's early comedy earnings resulted in half of a thirty-one-pound turkey.

Diller was in an unhappy marriage. According to her book, *Like a Lampshade in a Whorehouse: My Life in Comedy*, Diller's husband had difficulty keeping jobs, which put financial pressure on her. The couple had five children. After living in different homes throughout the island,

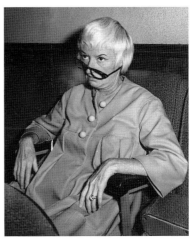

Phyllis Diller's reaction after seeing herself in her first film in 1961. *Courtesy of San Francisco History Center/San Francisco Public Library.*

they finally landed in the Fernside neighborhood, which Diller called "the Beverly Hills of Alameda." This was around the time a co-worker suggested she see a comedienne at the Purple Onion in San Francisco.

When Diller walked into the small, eighty-person club, she was inspired when she saw comedian Jorie Remus. Remus previously performed across the street at the hungry i. Banducci was not impressed, but Remus's band member, Keith Rockwell, was. The Purple Onion club was overflow for the hungry i. A show at the Purple Onion usually included a comedian, a dancer/singer and a headlining musical group. Often the audience included tourist buses that stopped to see local entertainment. It is the club where many musicians, comedians and poets got their start, including Diller, the Kingston Trio, Smothers Brothers and then dancer Maya Angelou. Remus and Angelou were coached by writer Lloyd Clark.

In Remus, Diller could see her own potential. Previously, she had burned her college scrapbook in the fireplace of her living room. The action symbolized the loss of her dreams to be an entertainer. Soon after, Diller picked up the book *The Magic of Believing*, which shifted the paradigm for her life. She was able to be more deliberate about her career and consequently her life. Serendipitously, Diller attended a jazz show in Oakland where she overheard Clark talk and immediately engaged with him. They soon worked together to develop an act that Diller honed in military hospitals and women's clubs. All of this led to a Sunday audition at the Purple Onion

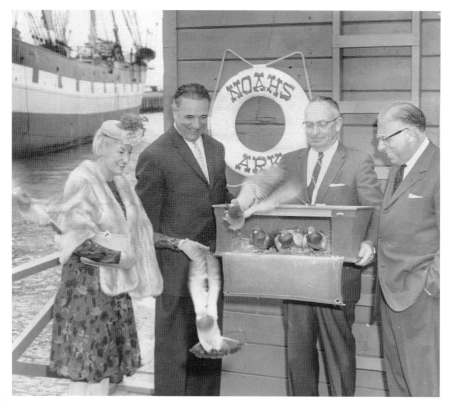

Phyllis Diller at opening day of San Francisco's Noah's Ark restaurant in 1959. *Courtesy of San Francisco History Center/San Francisco Public Library.*

for possible work during the week. Rockwell wasn't impressed by Diller. His sister and brother-in-law, Ginny and Bud Steinhoff, talked him into hiring her. In the coming months, she started to perform multiple times a night, sometimes sharing the stage with Maya Angelou, who eventually moved on when she got a part in *Porgy and Bess*. Diller was getting seventy-five dollars a week. Diller's first two-week stint turned into an eight-month run. Bud Steinhoff remarked in a 1975 interview celebrating twenty-five years of the Purple Onion, "You know how a lot of acts blame the audience if they don't go over....Well, she'd go back to the dressing room if she had a bad show and grade herself. 'What'd I do wrong.'"

Diller's comedic influence and eventual mentor was Bob Hope. Like him, she would belt out setups and punchlines that were common in the 1950s. She wore wild fashions that hid her voluptuous figure so that her jokes about her flat chest would work with audiences. When Playboy did a

Now at the **PURPLE ONION**
Rod McKuen ★ Maya Angelou ★ Phyllis Diller ★ Ketty Frierson
140 COLUMBUS CLOSED SUNDAY

Advertisement for the Purple Onion from July 30, 1955. Lineup included Rod McKuen, Maya Angelou, Phyllis Diller and Ketty Friersen. *From the* Oakland Tribune.

photoshoot as a goof, they had to strike the revealing photos because Diller had been tricking TV audiences and fans. She was not unattractive once she was stripped down. Similarly, once you stripped down the structure and traditionalism in her jokes, they were far from mainstream. She joked about the expectations of women's roles in the confining 1950s. Trapped in an unhappy marriage, she sublimated her grief into jokes. Maya Angelou offered this observation about her early co-worker: "[She] transformed the pain of her life and gave it to us as humor."

Diller found national fame on television and film. Her career spanned from the time she stepped onto the Purple Onion stage to her death at ninety-five in 2012. Diller performed live for decades while lending her voice to cartoons like *Scooby Doo* and *Family Guy* as Peter's mother. Diller's career achievements are plentiful, but she holds a special place for female comedians. She was the first woman to really break through in mainstream stand-up comedy. In an interview with Roseanne, who shared similar themes to Diller in her own stand-up and in her legendary sitcom, the two comedians reflected on making people laugh as female comedians. Diller reflected on the responses audiences initially had to her, "What is it? Get a stick! Kill it before it multiplies."

As we know now, female comedians did multiply because of Diller's groundbreaking appearances on TV and in clubs. In 1955, when she started, there were few female comedians who really hit nationally. Club comedians who were R-rated and the few who ventured on TV found little long-term success. There were also Black comedians performing in the Chitlin' Circuit like Moms Mabley who would not be welcomed onto network TV until the mid-1960s. Diller was the first to break through the glass ceiling of mainstream popular comedy.

THE SICK COMEDY OF SAN FRANCISCO

Close to Horror. What the sickniks dispense is partly social criticism liberally laced with cyanide, partly a Charles Addams kind of jolly ghoulishness, and partly a personal and highly disturbing hostility toward all the world. No one's flesh crawled when Jack Benny carried on a running gag about a bear named Carmichael that he kept in the cellar and that had eaten the gasman when he came to read the meter. The novelty and jolt of the sickniks is that their gags ("I hit one of those things in the street—what do you call it, a kid?") come so close to real horror and brutality that audiences wince even as they laugh.

Comedy of Chaos. The success of the sick comics has given amateur analysts and sociologists a field day. Says Novelist Nelson [The Man with the Golden Arm] *Algren: "This is an age of genocide. Falling on a banana peel used to be funny, but now it takes more to shock us. And there is no more fun in the old comedians. People nowadays would rather be hurt than bored." Says Irwin ("Professor"") Corey, who, at 45, is said by fans to have been a sick comedian before some of the others had their first case of measles or mother fixation: "The future seems so precarious, people are willing to abandon themselves to chaos. The new comics reflect this."*

In 1959, *Time* magazine published "The Sicknicks." The author calls the new generation of comedians who were redefining comedy the "sick comedians." These included many who performed in the nightclubs of North Beach; the article even cites the hungry i as one of the three national clubs where the comedians could be found. The author names Nichols and May, Shelley Berman, Jonathan Winters, Lenny Bruce and the "original sicknick," Mort Sahl.

Nichols and May, Winters and Berman helped to redefine live comedy and performance, which included monologues, skits and characters. All of these comedians performed often in North Beach clubs. One example of these performance innovations is Shelley Berman's one-sided pantomimed phone call to his fifteen-year-old daughter going out on her first date. In this skit, Berman affectionately guides his daughter on what to expect on a date, adding a nuanced delivery as he approaches the punchline: "The first kiss is his business, the second kiss is your business but the third kiss is my business." Berman's performance—having little awareness that the third wall is being broken with such personal content—is groundbreaking for the 1960s album

The Edge of Shelley Berman (1960), in which this bit appears. Winters and Nichols and May performed using similar techniques, leading the way for comedians like Lily Tomlin and Whoopi Goldberg whose theatrical presence makes one question where live comedy and theater begin and end.

The *Time* article acknowledges that comedians like Nichols and May were ranked low on its meter of "sick comedians." Although their humor expressed the sociocultural context of their time, it did little to outright challenge society in the ways that Mort Sahl and Lenny Bruce did. Bruce and Sahl directly challenged their audiences as well as the society they reflected. The term *sick* seems to be misconstrued by the author. Much like the acting out of a child in a dysfunctional family, these comedians' "sickness" was a manifestation of dysfunction in the system. The hypocrisy of American society was both the foreground and background to these comedians. San Francisco's bohemian culture with early challenges to free speech was the setting for Sahl and Bruce to explore the boundaries of stand-up comedy delivery and content.

Contrary to the original definition of the *sick comedian*, Lenny Bruce responded, "I'm not sick. The world is sick, and I'm the surgeon with the scalpel for false values." San Francisco's North Beach played a significant part in the development of Sahl and Bruce, which laid the comedic map for all those who would come.

MORT SAHL

"Are There Any Groups Here I Haven't Offended?"

Mort Sahl followed a girl from Southern California to Berkeley, where she was attending college in the early 1950s. He began to live a bohemian lifestyle in unstable living situations. He attempted to do dramatic theatrical work, but it was often heavy-handed and fell flat. Something was missing in his performance: direct messaging to his audience. He would later discover this voice and cultivate it at the hungry i.

Sahl auditioned for Enrico Banducci, who wasn't impressed by comedians, much less Sahl. That first night, Sahl packed out the hungry i with his Berkeley friends. Every modern-day comedian knows about "bringer shows," where a newer, unassuming comedian is obligated to "bring" friends and family to their performance for the sake of butts in the seats and hopefully laughs. Sahl's unofficial bringer show brought similar

Left: Mort Sahl in front of the hungry i's brick wall. *Courtesy of San Francisco History Center/San Francisco Public Library.*

Below: Interior of the hungry i with North Beach regulars, the Kingston Trio. *Courtesy of San Francisco History Center/San Francisco Public Library.*

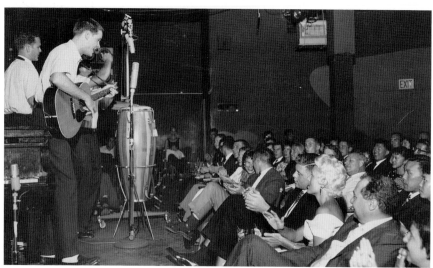

results. The first night he killed. The next night and after, he didn't. Audiences didn't respond like the friends did that first night, but Sahl worked on his act, studied the audiences and found ways to communicate his humor more effectively. Sahl spent his days combing through newspapers looking for that night's commentary and punchlines. It was common for him to have forty minutes of new material written in notes strategically placed in the iconic newspaper that he brought on stage with him. When Sahl started doing stand-up, the costume of the day was a suit. However, Banducci recommended Sahl wear a red V-neck sweater and loafers to conjure the casual look of a Berkeley intellectual. It is a look that Sahl embraced for the rest of his life.

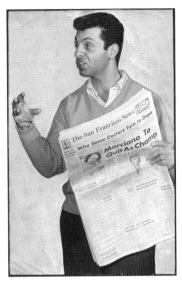

Mort Sahl holding the *San Francisco News. Courtesy of San Francisco History Center/San Francisco Public Library.*

Sahl's style was not the set-up/punchline structure that was common of comedians in the 1950s. The environment of the hungry i allowed him to explore different social and political topics. Most clubs will have the waitstaff bring drinks and take orders throughout the show. Not Banducci! He had his clientele order their drinks *before* the performance. The waitstaff would bring the two drinks for patrons to have during the show. That allowed for no interruptions for the act on the stage. If an audience member started to heckle the performers, Banducci would kick them out. He would also laugh during Sahl's set to signify to others that they should do the same. Setting the tone was important because no one had ever seen anything like Sahl. What made Sahl unique was his high intellectual expectations of the audience. He relied on them to read the paper and understand what he was talking about. Often his material went over their heads, so a little help from Banducci's laughing helped the audience go on the journey out of fear of looking stupid if they didn't join along.

Sahl soon became a hit and a fixture in North Beach. He started getting recognition in the local papers, and as a result, people came to see him. He blended well with the beatnik culture and intellectuals of North Beach that he also mocked. In 1955, he opened for Dave Brubeck, the jazz pianist, at the Sunset Auditorium in Carmel, California. The Bay Area Jazz label

Fantasy Records recorded and released the unauthorized album. Fantasy also produced Lenny Bruce's first album, *The Sick Comedy of Lenny Bruce* (1958), as well as the first albums by El Cerrito's Creedence Clearwater Revival. In spite of Sahl's album not being officially released with his approval, the album is historically significant. In 2011, *Mort Sahl at Sunset* was credited as the first modern stand-up comedy album by the National Recording Registry of the Library of Congress. Stand-up comedy albums would soon become a phenomenon in the development of stand-up comedy.

In years to come, Shelley Berman, Phyllis Diller and Dick Gregory would all have records. Bob Newhart's second album, *The Button-Down Mind*, would hit number one in its category on Billboard as well as win three Grammys, including Best New Artist. As of this writing, Newhart is the only comedian to win this category. Less mainstream but also popular were "party records." These records included blue material (dirty jokes) and were often played at get-togethers. Party albums were the perfect fit for comedians like Redd Foxx. The "comedy album boom" of the 1950s and 1960s promoted nightclub-style comedy that wasn't reflected on mainstream TV shows. It exposed new and diverse styles of comedy and comedians to the public, which in turn helped build the art form and industry for decades to come.

Unlike many of today's popular political comedians, Sahl took on *all* the politicians of his day. As the "loyal opposition," he was an equal opportunist in his mocking, going after conservatives *and* liberals to the dismay of some politicians and their supporters. For example, he poked fun, quipping, "Liberals...do the right things for the wrong reasons. So they can feel good for 10 minutes." After the assassination of John F. Kennedy, Sahl became disillusioned, almost obsessed with the subject. His attention to the case seeped into his stand-up, where he would talk about it and not stop. On his last night at the hungry i, Sahl raged on about the assassination and Banducci turned off the lights and kicked him off the stage. Other reports cite that it was not because of JFK but that Sahl was talking about Herb Caen, who had been good to the hungry i (and to Sahl until tensions grew around a woman they both knew), and that is why the lights turned off. Whatever the reason, the two would only work together once more at a hungry i reunion in the 1980s.

Sahl deconstructed stand-up comedy as it was in the 1950s. He was a writer, performer and improvisor all in one. He constantly worked on his act. Before him, comedians were not seen as smart, even though so many of them were. Sahl modeled a new intellectual brand of comedy that was revolutionary. Woody Allen remarked about Sahl, "Somewhere in the back

of my head I suppose I'd always thought about telling the jokes as well as writing them, but I'd never had the nerve to talk about it before. Then Mort Sahl came along with a whole new style of humor, opening up vistas for people like me....I didn't have the confidence, [but] I thought, my God, this guy's a genius, and I was inspired to want to do it [attempting stand-up]."

Mort Sahl changed the paradigm of comedy. Phyllis Diller did as well but in a different way. Both comedians had almost opposite styles. Diller never appeared as an intellectual on stage. She wasn't political, but if we consider that for women the personal is political, then she was equally revolutionary. Unlike Diller's punchy delivery and joke-oriented material, Sahl would meander in his stream of consciousness with the biting punchlines that raged against political and social issues. He was openly an intellectual who, naturally, disliked intellectuals and didn't hide it.

Lenny Bruce

Dissent from a world gone mad
—Ralph J. Gleason, album jacket of The Sick Humor of Lenny Bruce

Lenny Bruce's first big headlining gig in San Francisco was at Ann's 440 on April 1, 1958. The next day, a quote of his appeared in Herb Caen's *San Francisco Chronicle* column: "I'm just like everybody else. I want to be a nonconformist too!" It was also the same Caen entry in which he anointed the generation of bohemians in North Beach with the name *beatnik*.

Before booking that nightclub appearance at Ann's 440, Bruce was working in strip clubs as the emcee and house comedian. Around this time, he was cultivating a comedic voice that would influence generations to come and make him a martyr for free speech in comedy. While his earlier act was typical of the comedians of the 1950s, the morally free environment of low-

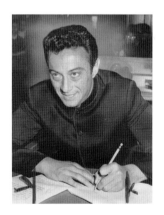

Lenny Bruce sitting in his Nehru suit for his trial.
Courtesy of San Francisco History Center/San Francisco Public Library.

stakes audiences at strip clubs liberated Bruce both in his style and content. It also placed him among jazz musicians who influenced his language and perspective in stand-up.

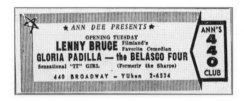

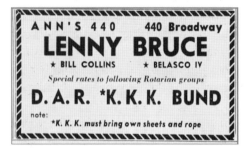

Top: Advertisement for Lenny Bruce's opening night at Ann's 440 on April 1, 1958. *From the* San Francisco Examiner, *March 29, 2958.*

Bottom: Advertisement for Bruce's subsequent appearance the week of June 6, 1958, after his extended stay at Ann's 440. The ad ironically invites the KKK to bring their own sheets and rope. *From the* San Francisco Examiner, *June 6, 1958.*

After Bruce's appearance in April 1958, he was held over for months. He was an immediate smash hit, hailed as "Ann Dee's answer to Enrico Banducci's Mort Sahl and Shelley Berman—the most refreshing humorist ole Baghdad's had in eons." One review of Bruce called him "insanely funnier than Mort Sahl," which was included on ads for the show. Other ads for Ann's 440 were cryptically and subversively funny, such as sayings in Latin like "Insolitis eat amare paves machinem catenem?" which translates to "Is it abnormal to love a cable car?" and one referencing that the "KKK must bring own sheets and rope." It was in San Francisco where the Lenny Bruce that so many revere crawled out of the burlesque club and onto the center stage.

During his months performing at Ann's 440, Bruce's career took off, which included landing his first record, *The Sick Humor of Lenny Bruce*, released by Fantasy records. The recording was from one of his performances at Ann's. The album includes classic Bruce bits like "The Kid in the Well" and "Religions. Inc." Bruce would go on to record several albums, many of which were recorded in San Francisco.

Bruce fully embraced the tenets of the Beat writers and jazz musicians and brought this soulfulness to comedy. It was not without controversy. Taking on issues like racism, sexuality, politics, drugs and all-around social norms didn't necessarily have a place in American culture in the 1950s. Bruce's comedy style wasn't punchy like Diller's stand-up. He was naked, and unapologetically so, as Bruce challenged society and called out hypocrisy in his act. Unlike Sahl, who focused on the political, Bruce

leaned more personal and included the most taboo of topics for the 1950s—sexuality. Mainstream America slowly caught on with predictable attempts to quiet him.

Bruce's censorship troubles started on October 3, 1961, at the Jazz Workshop, just across the street from Ann's 440. Many of his bits that night were considered obscene by the San Francisco police officer who attended the show, but there were three routines that stood out. One bit was a jazzy scat-like delivery exploring grammatical uses of the word *cum* (spelled "come" in writings about this material) as Bruce does an impression of a couple discussing why one of them is not able "to come." Another bit references a man with a sign over his penis reading, "When we hit fifteen hundred dollars, the guy inside the booth is going to kiss it."

The third bit has to do with his engagement at Ann's 440 and the gay culture surrounding the venue's history. In it, he plays himself and his agent talking about the upcoming gig. Those who know Bruce's style can hear the gruff voice he likely used for his agent to differentiate himself in the conversation, which went like this:

> *Lenny: What kinduva show is it, man?*
> *Agent: Well, ya know.*
> *Lenny: Well, no, I don't know, man…*
> *Agent: Well, it's not a show. They're a bunch of cocksuckers, that's all. A*
> *damned fag show.*
> *Lenny: Oh. Well, that is a pretty bizarre show. I don't know what I can*
> *do in that kind of show.*
> *Agent: Well, no. It's…we want you to change all that.*
> *Lenny: Well—I don't—that's a big gig. I can just tell them to stop*
> *doing it…*

As Bruce reminisced about the success of his first major San Francisco gig, he also challenged the absurdity of judgment on sexual orientation and sexual acts performed by men or women. The bit subtly reveals the transition from the roots of Mona's 440 and the well-established lesbian community yet did not directly address the lesbians who famously patronized Ann's 440 (in case you needed that pointed out). By voicing the gruff and homophobic agent, he highlights the heterosexual takeover of a LGBTQ nightclub.

At the end of his set, Bruce was arrested, booked on obscenity charges and released on bail in time for his 1:00 a.m. performance. In the patrol wagon, on his way to book Bruce, the police officer (who would later report

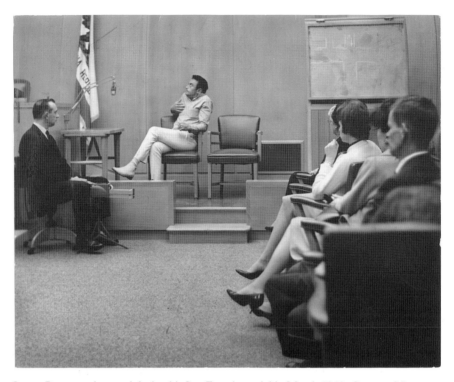

Lenny Bruce on the stand during his San Francisco trial in March 1962. *Courtesy of San Francisco History Center/San Francisco Public Library.*

this in the trial) asked, "Why do you feel you have to use the word *cocksuckers* to entertain people in a public night spot?" Bruce fired back, "Well, there's a lot of cocksuckers around, aren't there? What's wrong with talking about them?" Once back at the Jazz Workshop, in the improvisational and personal manner that became his stamp in comedy's evolution, he talked about his arrest, adding the now infamous line, "I'm sorry if I'm not very funny tonight, but I'm not a comedian, I'm Lenny Bruce." In March 1962, the short-lived obscenity trial of *The People v. Lenny Bruce* took place.

This was not North Beach's first obscenity case. City Lights Books (which still stands today) faced charges when it released *Howl* by Allen Ginsberg in the case of *The People v. Ferlinghetti*. The trial was heard by the same judge who would hear Bruce's case, Judge Clayton W. Horn. Publisher Lawrence Ferlinghetti was found not guilty of obscenity and *Howl* is still available to this day. As the written words of North Beach's artists were called into question for their decency, now it was Bruce's spoken words that were being charged.

During Bruce's trial, the prosecution had the North Beach police officer testify. The defense asked what else the police officer saw on his beat in the streets of North Beach, which included men in drag at Finocchio's and the Moulin Rouge strip club, to establish "community standards." The officer was also asked if Lenny Bruce's performance caused sexual arousal for him or others, as it is the intent of arousal that establishes an obscenity charge. Turns out it did not arouse the officer, nor did it seem to sexually stimulate the jury, which eventually (yet reluctantly) found Bruce innocent. One of the jurors said, "Under the letter of the law we had no choice...but we feel the obscenity laws of the State of California should be scrutinized and tightened." The chief of police of San Francisco, Thomas Cahill, "called for the law to be changed—free speech should not be *that* free."

People v. Lenny Bruce was the first but not the last trial for Bruce. More police officers and courts made it difficult for him to book work, elevating him to hero and eventual martyr of free speech status. *The Trials of Lenny Bruce* by Ronald K.L. Collins and David Skover characterizes the defense (and subsequently Bruce's comedy) as "social criticism aimed at exposing the hypocrisy and greed of the clergy; it was political commentary on racial discrimination and animosity toward homosexuals and other minorities; it was a satirical slap at the Establishment and self-righteous liberals. And all of this was done, the jury was told, consistent with the great literary traditions of Chaucer, James Joyce and Artistophanes."

Over the next four years, Bruce performed around the world, but San Francisco appearances were among Bruce's last performances. In 1966, Bruce performed at Basin Street West, which was one of the few venues in the United States that welcomed him. At this point, he was knee deep in obscenity charges in New York. Many considered Bruce to be personally obsessed about his case. His heavy drug use was apparent at his last performances at the San Francisco Fillmore on July 24 and 25, 1966.

On August 3, 1966, Lenny Bruce died at his home from a drug overdose. The court case never concluded. In 2003, Bruce was pardoned of the 1964 obscenity charge by Governor Pataki of New York. The case was brought to Pataki's attention thanks to a petition that was signed by many artists and social critics, some who even performed in Bruce's shadow in the North Beach clubs. These included Godfrey Cambridge, Margaret Cho, Dick Gregory and Robin Williams, as well as Tommy and Dick Smothers. In an interview with the *New York Times*, Tommy Smothers added, "So many of us today owe so much to Lenny Bruce."

Bruce's contributions influenced comedians for decades to come, but his comedy and legacy aren't just about breaking taboos or challenging free speech. Simply saying offensive or shocking things on stage for their own sake isn't the same thing. Lenny Bruce had the courage to express uncomfortable truths that challenged social norms of the time in the hopes of enlightening a precious few to see what he could see. Richard Pryor said of Bruce: "He is an original. He busted down doors and created a new fuckin' way to laugh…. He taught me not to go for the jokes to be funny; just tell the truth.…Telling the truth may get you hell but it also gets you to heaven. Thank you, Lenny. I love you man."

THE SMOTHERS BROTHERS

Tommy and Dick Smothers came to the Bay Area from their hometown in Southern California. They both attended San Jose State University, the elder Tommy first majoring in advertising and Dick studying to be a teacher. The brothers were introduced to music performance in high school. Tommy, being the more serious brother, focused on the guitar. The groundbreaking folk group the Kingston Trio heavily influenced the brothers, as the Trio's song "Tom Dooley" inspired many of the pair's later songs. The Kingston Trio came out of the Purple Onion, where they appeared alongside Phyllis Diller. The Trio also recorded one of their albums at the hungry i.

The Smothers Brothers started performing folk songs with both brothers singing and Tommy on the guitar. Tommy would introduce the songs. Their first paying gig was at a college bar, where they were paid in pretzels and beer. In a follow-up gig at the Kerosene Club in San Jose that catered to amateur acts and drunk college students, they queried the audience for anyone who could help them develop songs. Bobby Blackmore responded and quickly became the third and only non-brother member of the Smothers Brothers. They auditioned for the Purple Onion with Tommy on guitar, Bobby on tenor guitar and vocals and Dick only singing. During their set, someone in the audience spoke, and Tommy yelled at them to shut up, which got a laugh and charmed Drew Barry, the management. In February 1959, the group signed a contract to perform regularly at the Purple Onion. There were two issues that had to be addressed for the trio. The first was that Bobby was not an actual Smothers brother, so the group became The Smothers Brothers & Gawd, as suggested by Drew Barry. Barry went on to address the lack of an

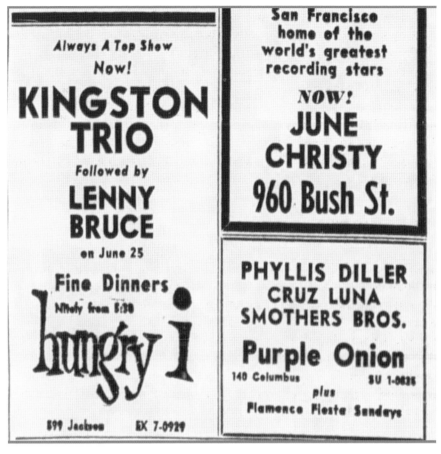

Advertisement as it appeared in the newspaper. Lenny Bruce performed at the hungry i while Phyllis Diller and the Smothers Brothers performed across the street at the Purple Onion during the week of June 7, 1959. *From the* San Francisco Examiner.

instrument for Dick. He suggested the upright bass. Tommy taught Dick a few tricks so he could fake it on stage.

The Purple Onion, which had recently lost the Kingston Trio to national fame, had a new folk group. Tommy would do the talk ups between songs with Blackmore and Dick playing and singing along. In the initial days of the Purple Onion appearances, Tommy would practice guitar while on the fifty-mile commute from San Jose to San Francisco. The Smothers Brothers & Gawd were held over at the Purple Onion for sixteen weeks. They began to develop away from the Purple Onion, touring outside of California and sharpening their skills. After six months, Gawd left the brothers only to later return for a TV reunion on *The Smothers Brothers Comedy Hour.*

The Smothers Brothers returned to the Purple Onion and recorded their first album on Mercury Records, *The Songs and Comedy of the Smothers Brothers at the Purple Onion!* (1961). Only one of the recordings on the album was truly recorded there, but the brothers were happy to include the club that gave them their big start on their album.

In time, the Smothers Brothers graduated from the clubs to a groundbreaking TV show, where, much like their North Beach brother Lenny Bruce, they encountered problems with censorship. The variety show took on societal issues like no other while simultaneously appealing to all ages in the family home. The short-lived show was canceled because of varying controversies but received an Emmy for Outstanding Writing Achievement in Comedy, Variety or Music in 1969. One of the writers on *The Smothers Brothers Comedy Hour* would later break out to become one of the biggest stars in stand-up comedy, headlining arenas in a manner comparable to rock stars. That writer, Steve Martin, also from Southern California, moved to the Bay Area in search of his comedic path through the coffeehouses and clubs of hippie-era San Francisco.

3

THE QUIET BEFORE THE STORM

BAY AREA COMEDY IN THE '70s

Throughout the 1960s, the hungry i and other venues remained a hotbed of modern stand-up comedy. Comedians like Woody Allen, Bill Cosby, Godfrey Cambridge and Professor Irwin Corey stretched the boundaries of the ever-changing art form in front of these audiences. Dick Gregory's first TV appearance was filmed at the hungry i for *Walk in My Shoes* (1961). The hour-long ABC docuseries features his performance and includes a backstage interview in which Gregory talks about comedy and activism.

As the 1960s came to an end, comedians who reflected political perspectives faded into the background as a combination of free thinking, creativity and possibly the use of marijuana spawned the folk singing-hippies and flower children of San Francisco. The beatniks transformed into something new. Down the street from the Co-Existence Bagel Shop in North Beach was Coffee and Confusion at 1339 Grant. It is where Janis Joplin, on the edge of fame in full-blown hippiedom, performed in 1963. It's also where (compared to his North Beach predecessors) a different style of comedy would emanate from a hippie-looking, banjo-playing comedian with long brown hair that would be turning gray very soon. His name was Steve Martin, and his soon-to-be-famous comedic voice would be cultivated in the city of San Francisco.

The 1970s brought about a more absurd comedic style, as if comedians were fusing the styles and content of both pre– and post–Mort Sahl comedy. David Allen, owner of the Boarding House and who formerly worked at the hungry i, reflected on this: "[Allen] thinks humor is simpler these days and

prefers funny people who aren't attempting to get a message across, but who prefer just to entertain....For years people were embarrassed to laugh at things that didn't carry some sort of message." The silly and absurd would be a new hallmark of San Francisco comedy in the 1970s. Nonetheless, these comedians were deeply thoughtful about their material and process.

The 1970s also brought new venues on television such as *Saturday Night Live* and comedy specials on HBO that would change the possibilities of both performance and exposure for comedians. Those who emerged in the 1970s strongly benefitted from these new opportunities. Although Johnny Carson's *Tonight Show* remained the ultimate TV appearance with star-making runs for comedians like Gabe Kaplan and Freddie Prinze, whose performances led to sitcoms, there were other, more edgy shows. Comedians like George Carlin, Andy Kaufman and Richard Pryor appeared on *Saturday Night Live* where, in the later time slot, they could approach more taboo subjects like racism, drugs and sex. Building on the long-playing structure and unfiltered nature of comedy albums, comedians were able to do longer than a ten-minute set thanks to cable specials on channels like HBO and Showtime. All of this opened up the possibilities of where comedians could be seen and what goals they set for themselves. Finally, comedians didn't only need a tight, clean five minutes for a late-night appearance. They could develop an act with depth and nuance. For many of the comedians who would rise to national fame in the 1970s and 1980s, San Francisco was the breeding ground for their material, unique perspective and style.

STEVE MARTIN

Before becoming the "wild and crazy guy" who sold out arenas, Steve Martin performed in North Beach's Coffee and Confusion on Grant Street. In 1965, he would drive up to San Francisco and see what work he could find doing stand-up. Coffee and Confusion is where Martin performed to an audience of none. Raised in Southern California, he worked and performed at Disneyland's magic show and Knott's Berry Farm. He eventually made the professional transition into writing for shows such as *The Smothers Brothers Comedy Hour*. After the cancellation of the *Comedy Hour*, he developed himself as a stand-up comedian, with much of his growth and significant milestones happening in San Francisco.

David Allen, who opened the Boarding House at 960 Bush Street, had seen Martin when he managed the hungry i. The Boarding House featured

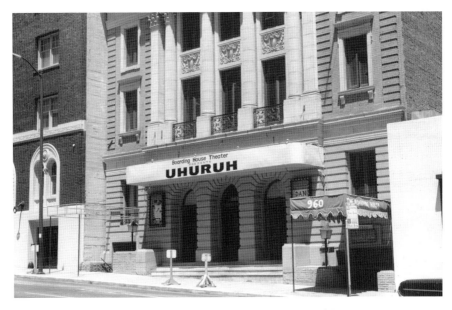

The original Boarding House at 960 Bush Street. *Courtesy of Jack Tillmany.*

mostly music in a big hall that sat over 200 attendees. In the smaller hall of the same building was "Allen's Alley," a dining room where up to 125 patrons saw some of the greatest comedians of the 1970s. Joel Selvin called the Boarding House "without a doubt, the finest nightclub in San Francisco of the rock era." Many musicians played there on their way to fame, including Elton John, Bette Midler and Oakland's the Pointer Sisters. Allen excelled at spotting talent that would be a good match for the San Francisco audience. The one exception was Barry Manilow. Manilow was booked by Allen the week that his song "Mandy" made the pop charts. However, San Francisco said "no thank you." as low attendance forced Manilow and Allen to cancel his late shows that week. The San Francisco audiences were equally discerning of stand-up comedy. The Boarding House introduced San Francisco to Martin Mull, Albert Brooks, Robert Klein and Lily Tomlin, the latter of whom would return often to develop her character-based comedy. The first comedian to headline was George Carlin in 1971.

Steve Martin experimented at the Boarding House with some of his gags and style that later became famous. It was here where Martin fine-tuned his dramatic goodbye bit that he uses in his movie *The Jerk*. At the end of his set, he would exit, proclaiming, "All I need is this…" and then proceed to pick up meaningless objects like ashtrays the very same way he

picks up a chair and paddle ball with his pants down to his ankles in the movie. Martin even went outside in between shows and entertained people about to come into the show. The Boarding House would be the first place Steve Martin headlined. Martin was the first comedian to rise to rock star–like fame, playing arenas and outselling musicians with his albums during the peak of his career in the mid-1970s. Martin recorded three albums at the Boarding House: *Let's Get Small* (1977), *A Wild and Crazy Guy* (half the album, 1978) and *Comedy Is Not Pretty!* (1979).

The Boarding House at 960 Bush was eventually demolished to make way for 1970s-style condominiums and thus moved to the edge of North Beach at 901 Columbus Avenue. In previous nightclub incarnations, the venue once ran a three-week engagement with Abbott and Costello. Lily Tomlin was the first booked performer at the new location in 1980. The Boarding House was also the venue for a new TV show in the early 1980s produced by KQED (the PBS affiliate), *Comedy Tonight*. Unfortunately, the Boarding House was short-lived in its new location before operating under the name Wolfgang's. Today, Cobb's Comedy Club, the location's third (and most steady) home, is one of the San Francisco Bay Area's most popular comedy clubs.

DON NOVELLO

Father Guido Sarducci, the Gossip Columnist to the Vatican Newspaper

Don Novello was born in Ohio, but his well-known comedic alter ego, Father Guido Sarducci, was born in the Bay Area. Novello moved to Marin County in his late twenties. Novello worked in advertising while writing on his own. His then vocation would later influence him when writing his book *The Lazlo Letters*. In 1972, the developing Father Guido Sarducci persona allowed Novello to explore political topics in the guise of a non-American/outsider perspective. The chain-smoking Italian priest was the so-called gossip columnist and rock critic for the Vatican.

Ironically enough, Father Sarducci encountered divine intervention at a couple key points. The first of these "miracles" took place in 1972 where Novello found his notorious cape, a women's opera cape, at the St. Vincent De Paul's Thrift Store in San Rafael for $7.50. That very cape would be held as evidence when Novello, as Father Sarducci, was arrested at the Vatican in

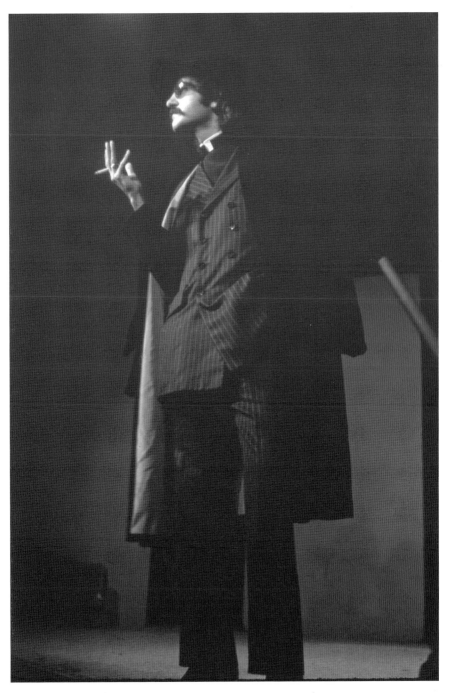

Don Novello as Father Guido Sarducci performing at the Intersection Coffee House. *Photo by Clay Geerdes, courtesy of David Miller.*

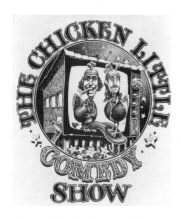

The Chicken Little Comedy Show. *Courtesy of Elisa Leonelli and Stuart Birnbaum.*

1981 on the charge of impersonating a priest. Novello reports he got the cape back and still has it in his Bay Area home. The second "miracle" would be where he developed his character, in a church basement on the edge of North Beach.

Father Sarducci first appeared on *The Chicken Little Comedy Hour. The Chicken Little Comedy Hour* was a Wednesday night show on channel 20 (KEMO-TV) on UHF. The pre–*Saturday Night Live* show offered different sketches, including a faux news segment that introduced San Francisco to Father Sarducci, whose tagline was "Europe is my beat." Some of Novello's sketches from the show would be recreated on the Smothers Brothers' TV show.

Soon after the *Chicken Little Comedy Hour,* Novello performed as Father Sarducci at the Intersection Coffee House, located in the basement of a church at 756 Union Street. The North Beach location was Intersection's second home after moving from 150 Ellis Street. St. John's Methodist Church on Union was failing and closed its doors. The church was rented to a ministry that blended spirituality with the arts, making the basement available to all kinds of events and workshops. The Intersection welcomed artistic experimentation without pushing a religious agenda. The goal was to bridge the church with younger generations of hippies through a connection with the arts. Karl Cohen coordinated movie and cartoon viewings in the basement that soon included live acts like Les Nickellettes and Cockettes, along with early career comedians Novello, Robin Williams and "Freaky" Ralph Enos.

At the Intersection, Novello breathed more life into the Father Sarducci character through his many performances. He also performed as Gianni Prosciutto, an Italian soccer player. Prosciutto was dropped, however, when Sammy Shore at the Comedy Store suggested he stick to one character. The Intersection was a small venue that had a comedy show twice a month. Novello described the show: "It was great.…It was known for the banana bread and every other week someone would forget to bring the bananas." Later it would be where Frank Kidder and Jose Simón held classes for aspiring stand-up comedians. The cost of admission for a show was seventy-five cents, the same price as bridge toll at the time. So Novello would make

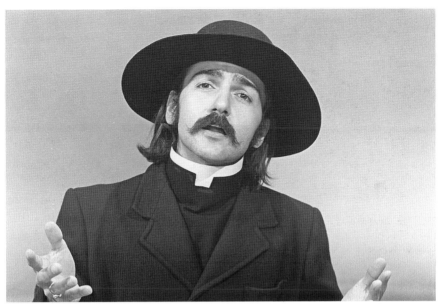

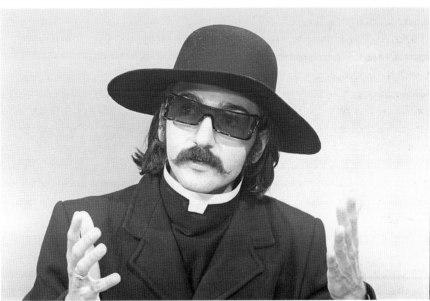

The first appearance of Don Novello as Father Guido Sarducci. *Photo by and courtesy of Elisa Leonelli.*

★★ INTERSECTION ★★
HOME OF THE NICKELETTES
FILMS 756 Union 397-6061 **SUNDAYS**
→ & LIBERATED VAUDEVILLE ←

WOMAN'S LIB ISN'T NEW

Sunday Nov. 4

NICKELETTES in "Long Lib the Nicks"
Freaky Ralph & his fantastic guitar

DANCING MOTHERS 1926 — A "kicky" film of the flapper era featuring the famous "It" girl, Clara Bow, and Alice Joyce. Directed by Herbert Brenon.
Clara's mother takes on a sexist society
a rarely seen sophisticated comedy/drama
CHARLIE CHAPLIN & Edna Purviance in Chaplin's Burlesque on Carmen (1915)
Charlie Chaplin & Mabel Normand, Mabel's Busy Day (1914)
Charlie Chaplin in The Masquerader (1914)
Bella Lugosi serial, The Whispering Shadow, ch. 9 (1933)
Snub Pollard in Years to Come (c.1923)
Betty Boop's Kerchoo
two camp newsreels about women
& Ripley's Believe it or Not, Land Without Women

live show at 8:30, films at 6 & 9:15
$1.25 donation (includes Mayor Nickeletto's Glitter Tax)

Clara Bow. the "IT GIRL"

EXPERIMENTAL CLASSICS

Sunday Nov. 11

City Clowns (& comic juggling)
Mime Ralph DuPont

Sergei Eisenstein's POTEMKIN (1925)
Norman McLaren's Pas de Deux (1970)
Leger's Ballet Mechanique (1924)
Pacific 231 with music by Honegger (1949)
George Melies, Trip to the Moon (1902)
Winsor McCay, Gertie the Dinosaur (1909)
Edison & Erwin S. Porter, Dream of a Rarebit Fiend (1906)
(based on a comic strip by Winsor McCay)
Walt Disney, Silly Symphony-Summer
Bella Lugosi serial, The Whispering Shadow, ch 10 (1933)

live show at 8:10, films at 6, 8:40 & 10
$1 donation

Gertie the Dinosaur

The Nickelettes & A Chaplin Marathon

Intersection's Fabulous Virgins in Residence
Freaky Ralph & special guest stars "Stinky & Pinky"
Don Novello as Father Guido Sarducci

Sunday Nov. 18

Charlie Chaplin in THE GOLD RUSH (1925)
plus Chaplin in: Easy Street (1917), One A.M. (1916)
The Pawnshop (1916), The Floorwalker (1915)
Bella Lugosi serial, The Whispering Shadow, ch. 11 (1933)

live show at 8:40, films at 6 & 9:20
$1.25 donation includes glitter tax

Gold Rush

THE SHADOW is UNMASKED!

Sunday Nov. 25

OVER 20 FILMS! An Orgy of action, comedy & cheap thrills

Bella Lugosi serial, The Whispering Shadow, Final Chapter
Charlie Chaplin's Shoulder Arms (1918)
Rudolph Valentino's Son of the Sheik (wild action, 1926)
Betty Boops - 3 with Cab Calloway:
Snow White, Old Man of the Mountain,
Minnie the Moocher
Everready's Burried Treasure (classic erotic cartoon)
excerpts from Marijuna, the Devil's Weed from Hell (1936)
Plus: aviation thrills newsreel, more comic TV commercials,
crazy Hollywood trailers, and more!

films at 6 & 9 pm. $1 donation

THE WHISPERING SHADOW

NICKELETTES	MAE WEST	HARLOW
Sunday DEC 2 Freaky Ralph stage show at 8:30 $1.25 donation	Klondike Annie at 7:25 & 10:30	Red Dust at 6 & 9:05

Intersection Coffee House flyer featuring the Nickelettes, Freaky Ralph and Don Novello as Father Guido Sarducci. *Courtesy of David Miller.*

two dollars after the cast split the money, seventy-five cents of which would go toward the bridge toll home. Like Mort Sahl, Novello would bring up a newspaper and riff off of the current events of the day, only with the non-American's political slant from the character's perspective. The audience's hippie sensibility of San Francisco welcomed the approach. Novello characterized the Intersection as "a great place to start because [the audience] was like performing to your friends."

Novello fine-tuned his act just as venues started to welcome comedy more. He found himself performing at the Boarding House. David Allen fostered Novello's comedic talent, suggesting a question-and-answer format with the audience, thus expanding Father Sarducci's range and further generating ideas and concepts within his improvisations. Novello then commuted to the Comedy Store in Los Angeles, where he was seen by David Steinberg and later suggested to be a writer and performer for the Smothers Brothers' show. Appearances as a writer and performer on *Saturday Night Live* were not far behind. After a long, fruitful career in comedy, as well as dramatic acting (see *Godfather III* for proof of that), Novello settled down and made his home in Marin County and has since performed at Comedy Day and at the last night of the Purple Onion, where Father Sarducci offered the historic club last rites.

RICHARD PRYOR

Sproul Plaza is at the busy intersection of Telegraph and Bancroft at the UC Berkeley campus. With stores and restaurants that cater to the college students, it is where the business district of Telegraph stops and the university begins. In 1964, a twenty-two-year-old Italian American man from New York who stuttered gave a speech in which he proclaimed,

> *There's a time when the operation of the machine becomes so odious, makes you so sick at heart, that you can't take part! You can't even passively take part! And you've got to put your bodies upon the gears and upon the wheels…upon the levers, upon all the apparatus, and you've got to make it stop! And you've got to indicate to the people who run it, to the people who own it, that unless you're free, the machine will be prevented from working at all!*
>
> —*Mario Savio*

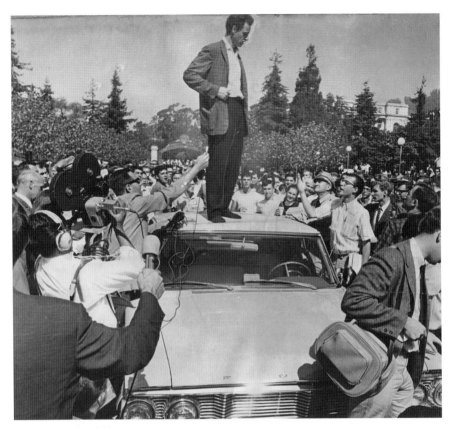

Mario Salvio delivering his speech from on top of a police car on the UC Berkeley campus in 1964. *Courtesy of San Francisco History Center/San Francisco Public Library.*

Mario Savio was one of the leaders in Berkeley's Free Speech Movement (FSM). Savio spent time in the American South, where he learned community organizing and protesting from Black civil rights activists. When he returned to Berkeley, he put what he had learned to use.

The FSM had many areas of focus, but the one that stood out was student activism. Before the FSM, students had barriers that the university constructed to curb protests. Savio and FSM activism helped to open up student activism across the United States. The movement also set the tone for years to come in Berkeley.

In Oakland, community activism had strong roots with the Black Panther movement in 1966. The new, more aggressive Black Power movement was led by Huey P. Newton and Bobby Seale. Oakland and Berkeley neighbor each other in the East Bay, just across the Bay Bridge from San Francisco.

In a matter of fifteen minutes (depending on Bay Area traffic), you could get from the Berkeley flats to downtown San Francisco. Berkeley and Oakland would become a place where leftist activism was common, free speech was valued and where Richard Pryor would come to discover his comedic voice and activist values.

While Berkeley and Oakland were becoming the cities we know today, Richard Pryor was working mainstream comedy gigs and appearing on national television, including appearances on *The Ed Sullivan Show* and *The Pat Boone Show*. One night around 1967 (or possibly 1968), Pryor stood in front of a Las Vegas audience at the Aladdin Hotel. He was making good money and, on this particular evening, performing in front of Dean Martin. Standing in the spotlight, looking out at the audience, Pryor questioned out loud, "What the fuck am I doing here?" A comedic and personal existential crisis took place in that moment. Pryor was questioning his relatively safe and noncontroversial comedy based on predecessors like Bill Cosby. The confines of mainstream entertainment restricted him from saying how he really felt. He needed a change, and in the coming months after stepping off the stage in Vegas, he came to Berkeley, California.

Many considered Pryor's time in Berkeley as transformative. Author and friend Cecil Brown characterized it:

> [The] *change that would not only transform his act, but would also transform the role of stand-up comedy forever. Pryor was possibly the only nightclub entertainer in America who would have thought to remake himself by moving to Berkeley, the capital of counterculture. Because of this single act he changed himself and twentieth-century American culture too.*

It was a creative time when his home base was on Berkeley Way until he moved near University and McGee. While on Berkeley Way, he lived with KPFA employee Alan Farley. The leftist radio station would also be where Pryor hosted a show titled *Opening Up*. While in Berkeley, Pryor regularly played at clubs like Mandrakes and Basin Street West in San Francisco. He also socialized with Berkeley and Oakland intellectuals, academics, artists and social activists. Exposure to new concepts and freedom to work new ideas and style out on stage helped Pryor develop a voice that embodied a more well-informed view of American life, including topics such as racism and sexuality.

Brown theorizes about the comedian as a shaman. He writes, "Like a shaman, Richard brought out the demons in society; and by purging

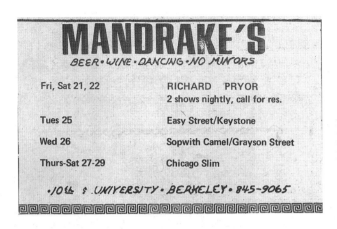

Advertisement for Richard Pryor's engagement at Mandrake's in Berkeley for week of May 21, 1971. *From the Berkeley Tribe, May 21–27, 1971.*

the society of those demons, he helped maintain some measure of sanity in society." Pryor is one of the best examples of this notion in stand-up. Pryor's time in the East Bay was the impetus behind his growth into one of the most influential comedians of the twentieth century. Taking what comedians like Mort Sahl and Dick Gregory established, he wove together the political, social and personal while making it hilarious and, in many cases, timeless.

ROBIN WILLIAMS AND THE HOLY CITY ZOO

According to his book *Dangerous Laughs*, Jim Giovanni was the first comedian to step foot on the stage at the Holy City Zoo (also known as the Zoo) at an open mic night. Eventually, more comedians began to share the stage with the mostly folk acts who flocked to the Clement Street venue in the Richmond District neighborhood. In the coming years, the Holy City Zoo would carve its place in the history of San Francisco comedy. Not only a stage to entertain and experiment, the Zoo became San Francisco's comedy headquarters.

In 1977, Giovanni was being scouted for a reboot of the 1960s variety comedy show *Laugh-In*. Producer George Schlatter came to the Zoo and brought four comedians back to Los Angeles. They were Giovanni, Toad the Mime (Antoinette Attell), Bill Rafferty and Robin Williams. Although a native of Michigan, Williams attended Redwood High School in Larkspur, California. After studying at College of Marin, he went to New York to learn the craft of acting. The East Coast didn't mesh well with Williams's West Coast eccentricities. He moved back to the Bay Area

Exterior of the Holy City Zoo. *Courtesy of San Francisco History Center/San Francisco Public Library.*

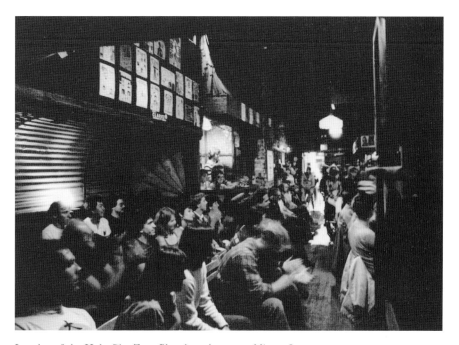

Interior of the Holy City Zoo. *Photo by and courtesy of James Owens.*

and started doing stand-up. He performed often at the Holy City Zoo, the Intersection Coffeehouse and the Boarding House, where he first headlined a club.

The new *Laugh-In* was not a success, but it did lead to the *Great American Laugh-Off*, filmed in San Francisco at the Great American Music Hall, a venue for comedy and music that's still open today. America would be introduced to the manic performance stylings of Williams in his 1977 stand-up television debut. He soon moved to Los Angeles with his wife, whom he met while bartending at the Holy City Zoo. While performing at clubs like the Comedy Store, Robin appeared on a single episode of *Happy Days* playing an alien. Soon after, fed by the popularity of *Star Wars*, Mork from Ork was born, or presumably hatched (that's how Mork was born on the show). The resulting spinoff show *Mork & Mindy* became a sensation after its premiere in 1978. Much like the *Star Wars* phenomenon, toys, lunchboxes and Mork dolls appeared in stores all over. Williams was the biggest success San Francisco comedy had produced at the time and could likely be the most successful we will ever have.

Although Williams made the move to Los Angeles, he never truly left San Francisco. He often returned to do shows at the Great American Music Hall and would sometimes drop in at the Holy City Zoo. Before him, Mort Sahl was the comedic measuring stick for people to use when talking about San Francisco comedy. Many articles still referenced Sahl in the late 1970s. After Williams's initial popularity, he became the new standard of what could come out of Bay Area comedy (as if anyone could ever measure up!). Like Sahl, he carried the torch for improvisational comedy and brought it to new heights of exposure and high-energy performance. Unscripted comedy would be heavily associated with San Francisco comedy. Comedian Dan St. Paul commented on the view of Bay Area comedians by Los Angeles standards: "San Francisco comedians can do twenty minutes but they can't do a [tight] five."

After his success in Los Angeles, Williams moved back to the Bay Area and never fully retired from stand-up the way that Steve Martin did. In addition to acting in films, Robin had numerous stand-up specials and albums, as well as the popular benefit show helping America's unhoused communities, *Comic Relief*. He remained active in Bay Area comedy, befriending many local comedians and supporting major events like San Francisco's Comedy Day. Williams was also often seen at local comedy shows, mostly at the Throckmorton Theatre in Mill Valley.

Williams forever remains an important part of Bay Area comedy. Many comedians and fans benefited from his friendship and kindness. Because of his important role in Bay Area comedy, this won't be the last you hear of him.

It also won't be the last you hear about the Holy City Zoo.

4

BAY AREA COMEDY RENAISSANCE

When I started out [in stand-up] there were about half a dozen serious comics in town…now there are about thirty," reported Bill Rafferty in 1978. That number would jump leaps and bounds throughout the 1980s and beyond. Thanks to Mort Sahl and Robin Williams, the comedy bar was raised in San Francisco, resulting in a comedy renaissance of the late 1970s and early 1980s. Mark McCollum, comedian and winner of the then third annual San Francisco Comedy Competition, predicted that for San Francisco comedy, "The '80s will be the '60s actualized." This was quoted by Bob Ayres, owner of the Other Cafe, the first full-time comedy club in the Bay Area, who added, "Comedy will flower."

San Francisco comedy was about to experience an emergence built on the foundation established by the comedians of North Beach. Many of its comedians would find career success in the Bay Area and beyond. They would also find financial success as working comedians making a middle-class living performing full time, something that is nearly impossible to do today.

Comedy in San Francisco expanded, as it did across the United States and eventually onto television. Live comedy was everywhere from hotel conference rooms, back rooms in Italian restaurants and bowling alleys across the country. Bay Area comedy legend Larry "Bubbles" Brown estimates the comedy boom ranged from 1984 to 1991, yet some claim it started in the late 1970s. Nearly overnight, music venues and discos turned into comedy clubs all over the place.

Top row, *from left to right*: Will Durst, Kevin Meaney, Fran Solimita and Jan Solimita. Bottom row: Barry Sobel, Steven Pearl and Jeremy Kramer. *Photo by and courtesy of Jeannene Hansen.*

Until the late 1970s, comedians in San Francisco were mostly on shows supporting a musical act, often folk or jazz. Later it dawned on club owners that comedy could stand on its own, as people would come just to see the comedians. San Francisco comedy clubs brought comedians from all over the country in addition to developing local talent, often before their next stop, Los Angeles. So many comedians came out of this era reaching national prominence that it is difficult to name them all: Dana Carvey, Ellen DeGeneres, Paula Poundstone, Whoopi Goldberg, Bobby Slayton, Tom Kenny (the voice of SpongeBob), Bobcat Goldthwait, A. Whitney Brown, Rob Schneider, Margaret Cho, Kevin Meaney and Kevin Pollak, just to name a few. San Francisco has always been a place for comedians to experiment and evolve their ideas into something more. Steven Pearl observed, "We could make our mistakes and not be seen by big Hollywood…and get better and better and better." He goes on to add, "There was such a great army of comedians back then….You had your

Paula Poundstone with Rick Reynolds, Kit Hollerbach and David Scheuber, and in the far distance is Tom Scheuber at Fisherman's Wharf. *Photo by and courtesy of Jeannene Hansen.*

work cut out for you. You have to follow any of them or work with them… you have to be good."

Comedy clubs across San Francisco were geographically spread out. Dan St. Paul said he could get in four sets a night and even get paid for them. Milt Abel seconded that experience. From the first night he moved to San Francisco, he performed every night for three years. A comedian might start their night at Cobb's Comedy Pub (Marina, later in Fisherman's Wharf before moving to North Beach), head to the Punch Line (Embarcadero), run to the Other Cafe (Haight-Ashbury) and end up at the Holy City Zoo. The Zoo was a common final destination, making it San Francisco's comedy "club house," as described by Debi Durst.

Right: A. Whitney Brown, Gil Christner and Tom Kenny hanging out. *Courtesy of Bob Ayres*.

Below: Assembly of many of the owners and producers of Bay Area comedy. *Courtesy of Bob Ayres*.

Outside of San Francisco, there were shows and nightclubs that sprouted during this time. The "giggle joints" listed in the *San Francisco Chronicle* in 1985 include San Francisco's Cobb's Comedy Pub, Punch Line, Other Cafe, Holy City Zoo (also listed as Ha-Ha A Go-Go when under different ownership) and Valencia Rose, as well as Tommy T's (San Leandro), Jeremiah's (Santa Rosa) and Rooster T Feathers (Sunnyvale). In years to come, other clubs would open in addition to established clubs adding more locations, including multiple Tommy T's clubs (San Ramon, Concord and, lastly, Pleasanton today), San Francisco & San Jose Improv, Fubar's (Martinez), Punch Line (Walnut Creek) and the Other Cafe (Emeryville). Additionally, comedians could find work just outside the Bay Area in places like Santa Cruz, where many middle acts would rise to headliner status. D. Durst estimated that her husband, Will, could work in the Bay Area for six months out of the year because there was so much work. The Other Cafe, the Punch Line and Cobb's were the main arteries for the San Francisco club scene, but for many comics, the Holy City Zoo remained the heart.

Holy City Zoo:
The Heart of San Francisco Comedy

"The Zoo! What a lovely hell hole," explained D. Durst. "When you killed, you killed because the place was so tiny. And when you died, you died because the place is so tiny." D. Durst began doing improv in the mid-1970s at the Spaghetti Factory in North Beach with a troupe who called themselves Spaghetti Jam. Years later, Spaghetti Jam hosted the open mic night at the Punch Line. That is when she met her would-be husband, Will Durst. The two were mainstays in the comedy community for decades to come. Will would go onto to win the San Francisco Comedy Competition, and Debi is the most recent lead organizer for Comedy Day. Holy City Zoo, for the Dursts, would be an emotional and financial investment for years.

For many comedians, the Holy City Zoo was their first time on stage performing stand-up. Larry "Bubbles" Brown was working a clerical job when he realized his ability to tell jokes at work either "made people laugh or annoyed them." A natural to comedy, it was his third time on stage at the Zoo when he received a standing ovation with deadpan delivery and lines like, "You're a nice-looking audience, too bad you're going to get old and die." "Bubbles," as many of his friends called him, would go on to achieve a David Letterman record of having the longest gap (twenty-one

Above: Larry "Bubbles" Brown posing in from of the Holy City Zoo. *Photo by James Owens and courtesy of James Owens.*

Opposite, top: October 1983 calendar for the Holy City Zoo. *Courtesy of Jeannene Hansen.*

Opposite, bottom left: Will and Debbie Durst in a photo shoot. *Photo by and courtesy of Jeannene Hansen.*

Opposite, bottom right: Larry "Bubbles" Brown's third time on stage while performing at the Holy City Zoo. *Photo by James Owens and courtesy of James Owens.*

years) between appearances. He was on both *Late Night* on NBC and *The Late Show* on CBS.

For Brown's first Letterman appearance, he immediately left 30 Rockefeller Plaza to catch a plane back to San Francisco. A friend picked him up at the airport, and they drove directly to the Holy City Zoo. Like many comedy clubs, the television was tuned to the show that their local comedian and

Dan St. Paul and Sue Murphy performing at Cobb's Pub. *Courtesy of Dan St. Paul.*

friend would be on. As Brown walked into the Zoo, the 12:30 a.m. show was more than half over. The comedian segment on Letterman always aired at 1:20 a.m. Brown was able to see himself introduced by Letterman and then watched his set at the same club he started in.

Dan St. Paul's first time on stage also happened at the Holy City Zoo. On December 30, 1980, Dan St. Paul and Sue Murphy performed for their first time at the Holy City Zoo's open mic night. The two actors previously performed together in local experimental plays. The Bay Area natives had practiced and polished their routine since May of that same year. The eight months of practice paid off. With impeccable timing and well-rehearsed material, Murphy–St. Paul killed. They did so well that they were invited to perform a seven-minute set the next week. With their newly found confidence from their first performance, the duo returned to the Zoo and "ate it," according to St. Paul. When their material missed, they didn't know how to respond to get out of this comedy misfire. They were approaching stand-up as theater without acknowledging the removal of the fourth wall. In years to come, they would figure it out.

St. Paul fondly remembers a sense of camaraderie in comedy back then, especially at the Holy City Zoo. Comedians seemed to genuinely like one another. Naturally, as is the case with comedians, there was jealousy as well as imitation. St. Paul observed that after Jake Johannsen appeared on

 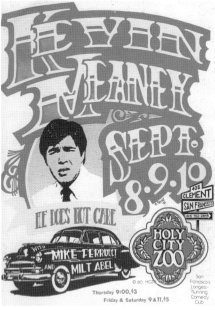

Left: Evan Davis and Mark Pitta performing at the Holy City Zoo. *Photo by and courtesy of James Owens.*

Right: Advertising poster for Kevin Meaney at the Holy City Zoo. *Courtesy of Jeannene Hansen.*

Late Night with David Letterman, others started to mimic him, as if "glasses, dressing in weird suits and stammering were what late night producers were looking for." Aside from occasional jealousies, St. Paul said the comics at the Holy City Zoo were tight. Comedians from all over the country would find themselves hanging out at the Zoo when they were in town, and on any given night Robin Williams might pop in and bump any lesser-known comedian in the lineup.

SAN FRANCISCO VENUES AND BEYOND

A plethora of clubs and showcases across the Bay Area lent themselves to paid opportunities for budding comedians. These venues supplied the backdrop where comedians, concepts, styles and characters made their debut. What made San Francisco's comedy scene unique was that up until the late 2010s, comedians could travel to and from San Francisco to Oakland, San Jose, Contra Costa County and even as far as Modesto

and Santa Cruz to perform. With tech industry traffic congestion today, Myles Weber, a comedian of today's generation, felt the porous nature of San Francisco comedy started to subside. But this was not the case during the comedy boom. Comedians could find work and audiences across a one-hundred-mile radius. Naturally, there were demographic and cultural differences between San Francisco and the rest of the Bay.

Some comedians who did well in San Francisco didn't necessarily do well outside of the city. Milt Abel remembers that the reputation of San Francisco comedy was "being artsy-fartsy stand-up…weird for weird's sake." Abel went on to convey a story, unsure if it was true or folklore, that demonstrates how San Francisco comedy was perceived by the rest of the Bay Area and even nationally:

> San Francisco audiences were closer to a theater audience than a bar audience, I guess would be a good way to sum up. There was a story of a club owner who was paying the middle act while a well known San Francisco comic was headlining. Apparently the owner could hear the crowd reaction dissolve in his room. In his office, the owner says, "You hear that?!" gesturing toward the stage. The comic said, "I don't hear anything." Finally the owner sarcastically says, "That's art!"

Needless to say, not all San Francisco comedians translated or adapted well to the East and South Bays, or beyond, where many showcases and clubs flourished throughout the comedy boom. Additionally, if comedians didn't feel easily accepted by the San Francisco comedy scene and its audiences, many found a home across the bay.

The Other Cafe

The Other Cafe was a folk venue in the middle of the hippie epicenter of the Haight-Ashbury. As the hippie era came to a close, the venue transitioned to stand-up comedy. Bob Ayres, co-owner of the Other, bought the coffeehouse with a loan from his parents. Like many clubs, it hosted a headliner on the weekends and weekday showcases during the week. Popular headliners who had yet to reach superstar status in the 1980s, like Jay Leno and Jerry Seinfeld, packed out the small venue. The comedians performed on a stage where the backdrop was a window that looked on to the corner of Carl and Cole Streets. Naturally, the literal window to

Above: Exterior of the Other Cafe. *Photo by and courtesy of Jeannene Hansen.*

Right: Jeannene Hansen performing at the Other Cafe. *Courtesy of Jeannene Hansen.*

Above: Early calendar from the Other Cafe before it turned into a comedy club. Note Jane Dornacker's band Leila and the Snakes playing throughout the month. *Courtesy of Bill Ayres.*

Opposite: Roast of Bob Ayres on the fourth anniversary of the Other Cafe. Comedians included Jeremy Kramer, Jane Dornaker, Michael Pritchard, Bob Sarlatte, Dana Carvey, Darryl Henriques and Kevin Meaney. *Courtesy of Bob Ayres.*

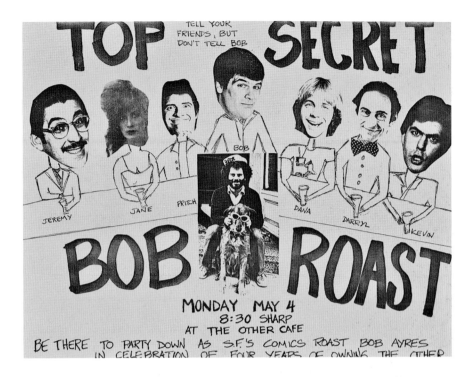

the active community of the Haight-Ashbury District supplied comedians with opportunities to use the improvisational skills that San Francisco was known for.

One night out of the week, comedians were not allowed to perform previously used material. None! Paula Poundstone was the longstanding host at the Other's open mic. That is where she first analyzed the nuance of how one comes to eat an entire box of Pop-Tarts. At an Other Cafe open mic in late 1984, a high school student named Margaret Cho appeared for the first time on the suggestion of her dramatic arts teacher. Cho and her improv partner, Sam Rockwell, soon performed at the Other regularly. In the 1990s, Cho went on to break barriers for Asian Americans on TV with her show *All-American Girl*.

Dana Carvey was another regular at the Other Cafe, as were his later *Saturday Night Live* co-stars Nora Dunn and A. Whitney Brown. In the mid-1980s, *Saturday Night Live* hit a slump with its hip, young cast that included Brat Packers Robert Downey Jr. and Anthony Michael Hall. In one year, the entire cast and many writers were fired with only few remaining: Jon Lovitz, Al Franken, A. Whitney Brown and Nora Dunn. The last two were alums of the San Francisco comedy scene. The new cast introduced Dana

THE OTHER CAFE

AUGUST 5-9

AUGUST 12-16

AUGUST 19-23

AUGUST 26-31

SEPTEMBER 2-6

COMEDY THEATER MONTH

Carvey, whose collection of characters redefined the show during his run. After winning the San Francisco Comedy Competition in 1977, he remained dedicated to stand-up and developing characters in his act. The established relationships of Dunn, Brown and Carvey paid off in the writers' room.

The characters and sensibilities developed on stage at the Other Cafe, Punch Line and the Holy City Zoo came alive in the SNL season of 1986–87: the Sweeney Sisters, the Pat Stevens Show and, most famously, the Church Lady. The new cast was considered by many as one of the best ensemble casts since the original Not Ready For Prime Time Players. Rob Schneider, another San Francisco comedian who started at the Holy City Zoo before he was of legal age, also joined the cast of *Saturday Night Live* from 1990 to 1994.

Before *Saturday Night Live*, Dana Carvey met two important women in his life at the Other Cafe: his wife, Paula, and his Church Lady character.

> *The Church Lady was developed at the Other Cafe, but I can't take all the credit.…One night after a particularly strong set, Bob Ayres came up to me and put his hands on his hips and said, "Well, isn't that special?" I froze in my tracks. I loved the sound of it, the rhythm. I thought to myself, "Isn't*

Opposite: Calendar from the Other Cafe. *Courtesy of Bill Ayres.*

Above: Dana Carvey shaking hands with Bob Ayres at Ayres's roast. *Photo by and courtesy of Jeannene Hansen.*

Kevin Meaney performing at the Other Cafe's club (El Otro Café) in Puerto Vallarta. Earlier that day, Meaney had carne asada from a street vendor. *Courtesy of Bob Ayres.*

> *that special?" Yes, I can work with that. I asked Bob for a pen and began*
> *writing furiously. Just then, Chip Romer came up and said, "Hey, Dana,*
> *who are you writing that note to—Satan?"*

Truly an inspired moment that would later come to life on *Saturday Night Live*, making Dana Carvey and his characters household names.

The Other Cafe would expand to Emeryville and even to Mexico, but the San Francisco location was its most successful and legendary.

Punch Line–San Francisco

In October 1978, the San Francisco Punch Line opened at its current space at 444 Battery Street. It was located next to the Old Waldorf music venue. In fact, the club served as the dressing room for the Waldorf. The Punch Line was owned by Bill Graham but run by a married couple, Jon and Ann

Left: David Feldman at the San Francisco Punch Line with the early background of the skyline. *Photo by and courtesy of James Owens.*

Below: Larry "Bubbles" Brown in the green room at the Punch Line. *Photo by and courtesy of Jeannene Hansen.*

Fox, who co-produced the San Francisco Comedy Competition. The club accommodates 180 seats and famously sports a mural of the San Francisco skyline as the stage backdrop. Today, it is San Francisco's longest-running comedy club.

In 1978, a short three-paragraph blurb from the *San Francisco Examiner* stated that there would be a headliner from Wednesday to Saturday and a new talent showcase on Sundays. That week, Jim Giovanni headlined with Jack Marion opening. Jose Simón hosted the Sunday Showcase. The Punch Line fast became a staple in the San Francisco comedy community. It would be a place where comedians could get paid work (especially on the weekends) as hosts or feature for an out-of-town headliner. The Punch Line later opened additional locations in Walnut Creek and Sacramento. The Sacramento location remains open today.

Steven Pearl makes the distinction between the Punch Line and the Holy City Zoo: "I really liked the Punch Line, and I really liked the Holy City Zoo, which are two opposites actually. The Punch Line, you could feel like you're really uptown there. It was just like being on a cruise ship or like a Vegas lounge or something. It's very nice. And the Holy City Zoo was a dive, but a lot of magic went on there." Pearl and Bobby Slayton would appear often at the Punch Line and achieve a local rock star–like status with help from Alex Bennett's listening audience on KITS FM Radio. The Punch Line would serve as a premier venue for comedy for decades.

COBB'S COMEDY CLUB

Susan Healy performing at the Holy City Zoo. *Photo by and courtesy of James Owens.*

Cobb's Pub was originally on Chestnut Street in the Marina District. Once a bar, it began booking comedy as the boom took off. Although the Cobb's Comedy website (CobbsComedy. com) cites its opening in 1982, there is an ad that ran in June 1981 to boost its "gala opening" on July 10, 1981. The comedy troupe Femprov headlined with Jeremy Kramer and Dr. Gonzo opening. Femprov arrived in a limousine with searchlights in front of the club.

Femprov was created in 1979 by Susan Healy, Terry Sand and Kristen Siem. Through the years, other women would filter in and out of the troupe. Many would springboard

Exterior of Cobb's Comedy Club (first location). *Photo by and courtesy of Jeannene Hansen.*

Photo of comedians on stage at Cobb's Pub with owner (*middle*). Included is Steven Pearl (*Montana shirt*), who was interviewed for this book and Tom Sawyer (*bottom*) who eventually bought and managed the club. *Photo by and courtesy of Jeannene Hansen.*

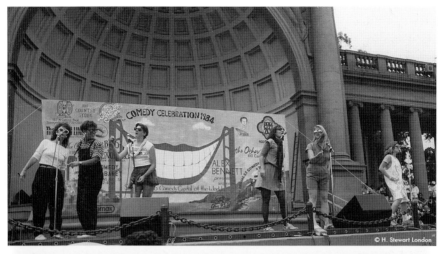

Top: Femprov performing at Comedy Day in 1984. *Photo by and courtesy of H. (Hank) Stewart London.*

Bottom: Ellen DeGeneres performing at Cobb's Pub. *Photo by and courtesy of Jeannene Hansen.*

into stand-up, such as Susan Healy. Other members of the group included Jeannene Hansen, Carol Roberts, Debi Durst, Linda Hill, Sandee Althouse, Pat Daniels, Barbara Scott, Teresa Roberts and Denise Schultz. In 1980, Femprov hosted a Wednesday night at the Holy City Zoo as well as matinee shows. The Wednesday show was an all-female night where women could develop their stand-up, improv and sketch in a female-dominant

environment. Femprov performed across the city. Learning from their own hustle in different clubs and venues, they were pivotal in the transformation of Cobb's Pub from a neighborhood bar to a comedy club.

Terry Sands, a member of Femprov, worked with the owner of Cobb's Pub, Ron Kakiki, to set up the club. This included the design of the stage, booking/scheduling and public relations. For the first three months, Femprov headlined the club. This is where they experimented with live video in their performances, which was simulcasted onto a television on stage. The performers on the stage would then interact with the performers on the TV, thus adding an additional dimension to their improvisation.

The intimate 100-seat club inevitably moved to the more tourist-attractive Cannery at 2801 Leavenworth in 1987. The new location was an opportunity to rebrand as a more formal comedy club with 170 seats. Tom Sawyer, who started as a manager of the club on Chestnut Street, became an owner once it moved to its second home. The club became the second-longest-standing comedy club in the city. The club has changed hands and moved locations since Sawyer's ownership over the years. The present location is on Columbus Avenue, the building that was once home to the Boarding House and Wolfgang's.

TOMMY T'S

Tommy T's Comedy Club was initially situated in a strip mall in San Leandro, a suburban city in the East Bay that neighbors Oakland. A mural of vaudeville-era comedians like WC Fields on the exterior communicated to passersby that the once top-forty dance club of the late 1970s at the same address had transformed into a comedy club. What made Tommy T's unique was the location, proving that a full-time comedy club could work in the suburbs. It worked so well that new venues opened throughout East Bay cities such as San Ramon, Concord, Pleasanton and Rancho Cordova (near Sacramento), the last two of which Tommy T's Comedy Clubs found their most recent homes. Tommy Thomas, aka the "Tommy T" of Tommy T's, was called "the McDonalds of comedy" by morning radio personality Alex Bennett. Thomas was a Bay Area local and remained active in the Bay Area nightclub scene for decades.

The early months in San Leandro, when Tommy T's first opened, were rough. But the club persevered and attracted a regular audience. In a 1986 interview with the *San Francisco Examiner*, Sue Murphy commented, "From

Backstage in February 1987 in the Walnut Creek Punch Line green room. *Photo by and courtesy of Jeannene Hansen.*

the very beginning, and it was absolute hell....Most clubs would try comedy on Tuesdays for a few months, then go back to wet T-shirt contests, but he [Thomas] rode it out. He showed it could work in the suburbs." Norman Hazzard, who started in comedy in the mid-1970s, performed at Tommy T's in San Leandro. Hazzard and other comedians would end up at Tommy T's as their final destination, similar to San Francisco comedians' relationship with Holy City Zoo. The club started its shows late, which meant comedians could come hang out after other earlier booked shows. Hazzard described the audiences at Tommy T's and other showcases in the East Bay as more working class than the San Francisco audiences. "When you performed at Tommy's you had to be the *real deal*," Hazzard added. The East Bay audiences weren't shy about booing you off stage if you weren't performing up to their standards, unlike the more patient, nonconfrontational audiences in San Francisco.

Other Tommy T's clubs began to open in the late '80s and into the '90s. In 1989, the Concord location debuted. It soon after turned into a dance club and then changed back to Tommy T's in 1991. In 1993, it became a dance club again, this time with a country theme, Cadillac Ranch. Around 1995, the club was divided into two separate sections to accommodate dancing as

well as comedy. In May 2005, the Concord location closed permanently; Thomas no longer owned the club in its last two years. Similarly, Thomas no longer operated the San Ramon location, but he did loan the name to the club, according to longtime bartender Barbie Evers. The Pleasanton and Rancho Cordova locations remained open until the Rancho Cordova location closed just before the 2020 COVID pandemic. But up until then, and in Pleasanton to this day, Tommy T's books major headliners. Many comedians got their first opportunity on a showcase or as hosts at Tommy T's. With any luck, the newcomers would bring an audience to support the other comedians on the show. Tommy T's was possibly the most active comedy club during the pandemic, adapting to public health guidelines with outdoor shows and continuing to attract big-name headliners.

ROOSTER T. FEATHERS

A short blurb in the *San Francisco Examiner* in October 1984 announced that the Country Store in Sunnyvale, a music club for the past fifteen years, was going to "reemerge" in December as a comedy club. It would be named Rooster T. Feathers. Before it was the Country Store, it was Andy Capp's Tavern, historically the first location ever to display the Pong arcade game. The Country Store mostly hosted music, with one night a week dedicated to comedy or other popular bar activities of the 1980s. One week in 1983, it hosted Whoopi Goldberg and Bill Maher on the same bill on a Tuesday, with mud wrestling the following Thursday. Rooster T. Feathers is located in the heart of the ever-developing Silicon Valley, which grew economically in the '90s and afterward changed the economic structure of the entire Bay Area. Roosters hosted national headliners, local comedians and a yearly competition where the audience voted for their favored performer, up until the pandemic. Although Roosters awaits its post-pandemic fate, it and the San Jose Improv have reputations as the major comedy venues in the South Bay.

FANNING THE FLAMES OF SAN FRANCISCO COMEDY

The Bay Area comedy boom was elevated by national late-night shows and cable programming, as well as local TV and radio. KQED's *Comedy Tonight*, a one-hour show, featured full ten-minute sets from local comedians in front of a live audience. The PBS affiliate had earlier versions of shows that featured

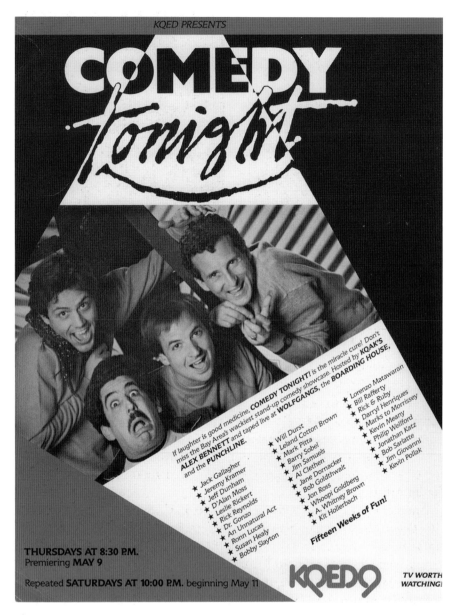

Above: Advertisement for Comedy Tonight on KQED. *Courtesy of Jeannene Hansen.*

Opposite, left: San Francisco's "Pitbull of Comedy," Bobby Slayton. *Photo by and courtesy of Jeannene Hansen.*

Opposite, right: Larry "Bubbles" Brown as alter ego "Bobby Bitter." *Photo by and courtesy of James Owens.*

BOBBY BITTER

comedy, including the *Barbary Coast Funnies. Comedy Tonight* premiered in 1981, was filmed at the San Francisco Punch Line and featured Dana Carvey, Bob Sarlatte, Jane Doorknacker and Bobby Slayton. Later seasons were filmed at the Boarding House, Wolfgangs and finally at the Great American Music Hall. *Comedy Tonight* was syndicated across the country on other PBS stations and gave many viewers their first peek at comedians like Bobcat Goldthwait, Kevin Pollack and Ellen DeGeneres. Frank Zamacona, the producer of *Comedy Tonight*, makes the claim that Whoopi Goldberg's television break was a direct result of her appearance on *Comedy Tonight*, since her appearance forced her to join AFTRA, the American Federation of Television and Radio Artists.

Another local station that helped promote Bay Area stand-up was KITS's *Alex Bennett Show*. Appearances on the local radio show allowed comedians to promote their weekend shows while audiences got to know them personally. Many comedians like David Feldman, Scott Capurro and Sue Murphy became regulars. Steven Pearl and Bobby Slayton had open invitations. "He'd make you a star in three area codes," Pearl remembered, adding that an appearance on the show could sell out the Punch Line that week. Out-of-town headliners often appeared on the show as well. Larry "Bubbles" Brown became the show's "traffic guy." KITS (later known as Live 105) sponsored comedy shows, some of which were live broadcasts on their morning show. This is where Brown performed alongside Feldman in his character Bobby Bitter, an intentionally edgier voice of Bubbles that would spout lines such

as "Atlanta's burning and so is my urine," which could go either way with audiences.

The promotion of comedy through media was nothing new in the 1980s. Television, radio and newspaper outlets helped bring stand-up comedians to a wider audience, blessing them with legitimacy in their craft and community. Don Novello cited Tom Donahue as being a promoter of Novello's work as well as other comedians in the 1970s. Newspaper columnists like San Francisco legend Herb Caen promoted comedians as well. It was common for Caen to offer quotes from comics like he did the day after Lenny Bruce first headlined Ann's 440. Carrie Snow was often cited in the column, and in 1990 she was the emcee for Caen's roast. Snow remembered fondly how much a mention meant: "You know, when he put my name in the paper, it made my father's day."

"THE PERFECT STORM"

Many of the comedians interviewed for this book talked about San Francisco being the perfect storm for stand-up comedy during the boom. The combination of the already established comedy scene, affordable housing for artists and ability to play multiple clubs and showcases without the need to become a road comic 365 days of the year all helped Bay Area artists make a middle-class living. Pearl remembers what it was like when he first moved to San Francisco in 1979: "Back then, the city was so cheap to live in. My rent was at a big old studio [in San Francisco] for 200 a month....It was just really cheap to live there. It was wonderful."

Because the level of talent in the comedy scene was so high, comedians raised each other up. If you were following Paula Poundstone, Dana Carvey or Bobcat Goldthwait, you had to be good. Since San Francisco comedians were free from being seen by Los Angeles agents or television bookers, they were able to experiment and develop their acts free from the pretentious self-consciousness that comes with the influence of industry onlookers. Pearl sums it up as San Francisco being a "good place to make mistakes and get better at your craft."

The improvisational style of comedy that Mort Sahl innovated and Robin Williams elevated to unseen heights was utilized by Bay Area comedians like Pearl, Poundstone, Carvey, Warren Thomas and Donald Lacy. Riffing a stream-of-consciousness into a black hole of absurdity was a staple of Bay Area comedy. Thomas, who was from San Francisco, started comedy in the

Bay Area Comedy Renaissance

Left to right: Blaine Capatch, Brain Posehn, Greg Behrendt, Patton Oswalt; *kneeling*: Laura Milligan. *Photo by and courtesy of Dan Dion*.

91

Closing day at the Holy City Zoo. *Photo by and courtesy of Jeannene Hansen.*

mid-1980s when he was at San Francisco State, alongside his friend Donald Lacy. Lacy, a comedian born and raised in Oakland, lovingly remembers his friend Warren Thomas, who died in 2005. Thomas encouraged Lacy to push the limits of his material with this advice: "'Squeeze every drop out of that rag.' And I never forgot that. So, whenever I got on a roll with a riff, I would always just go. [Warren] said, '[The audience] will tell you when it's over, you don't pull the rip cord.'"

Comedy in San Francisco flourished in the 1980s. The comedy boom fostered profits as well as stage time for comedians to feed on. It also produced too many comedians to name. Many of them made an impact and are still performing as comedians, writing or acting today.

As with all good things, the comedy boom came to an end. Many attribute the bust to the stand-up comedy people could consume on television for free. The very thing that brought live stand-up comedy to such prominence was also its detriment, at least as the 1980s knew it. D. Durst added that many clubs packed their audience with free tickets to benefit the bar tab. One Bay Area club would promise the comics "the door" (money made from ticket sales) but then give most of the tickets away for free. The club did well, but the comedians went away empty-handed.

The Dursts bought the Holy City Zoo in the early 1990s in collaboration with other co-owners. They own the venue's sign and trademark to this day. They couldn't bear to see their dear clubhouse go away forever. Unfortunately, the overhead was too high, and college students in the neighborhood who patronized the venue moved away. The last show at the Clement Street location was for a marathon show that went for forty-eight hours straight, ending at two o'clock Tuesday morning. The entire show was hosted by Jeremy Kramer, with Larry "Bubbles" Brown and David Feldman going up second to last and Will Durst closing out the legendary era. The Zoo permanently closed on August 3, 1993.

The Other Cafe (San Francisco and Emeryville), SF Improv, Fubars, Valencia Rose and the Walnut Creek Punch Line eventually closed as well. Bay Area comedy was reduced to the main clubs: San Francisco's Punch Line and Cobbs Comedy Club, Pleasanton's Tommy T's, the San Jose Improv and Rooster T. Feathers. Nonetheless, showcases and open mics continued to pop up in bars, restaurants, sporting goods basements, laundromats and whatever venue would welcome comedy. San Francisco would foster a tech bubble in the mid-1990s, but artists were still able to live affordably. As the tech boom of the 2000s came, so did gentrification, which drove out many deeply rooted San Francisco communities in favor of market-rate rents. The economics of San Francisco brought a change to the culture itself, which would trickle its effects into Bay Area comedy.

5

SAN FRANCISCO COMEDY'S RITES OF PASSAGE

Every culture has rites of passage. These rituals tell people if they are in or out of the group and where they fall in the pecking order. Some rituals are initiations into the group. Others are hazing rituals set to usher its participants through one threshold and onto the next. Dan St. Paul observes that for San Francisco comedians, "There are two rights of passage in Bay Area comedy: the San Francisco Comedy Competition and Comedy Day."

SAN FRANCISCO COMEDY COMPETITION

Many call Frank Kidder the founder of the San Francisco comedy scene. This is literally accurate considering that in March 1973, he founded the San Francisco Comedy Scene, a two-hour show at 9:30 p.m. on Friday nights at the Intersection Coffee House. The workshop-like environment was a place where Kidder fostered and coached comedy in an effort to nurture the post-hippie/pre–comedy boom comedians. According to Kidder's future collaborator, Jon Fox, he and his wife met with Kidder, where they learned, "Frank had been involved in a terrible car accident, running into an oak tree at over one hundred miles an hour. He lived. The tree died. While recuperating in a hospital, another patient had cracked a joke which made everyone on his ward feel better. There and then he had decided to dedicate himself to creating laughter in the world. The design on his stationery was a drawing of that oak tree." In a 1975 interview,

Above: Frank Kidder (*left*) and Jose Simón (*right*) at Comedy Day. *Photo by and courtesy of Barry Katzmann.*

Left: Myles Weber looking onto the empty theater he will perform at for the 2015 San Francisco Comedy Competition. *Photo by Heather Weber, courtesy of Myles Webber.*

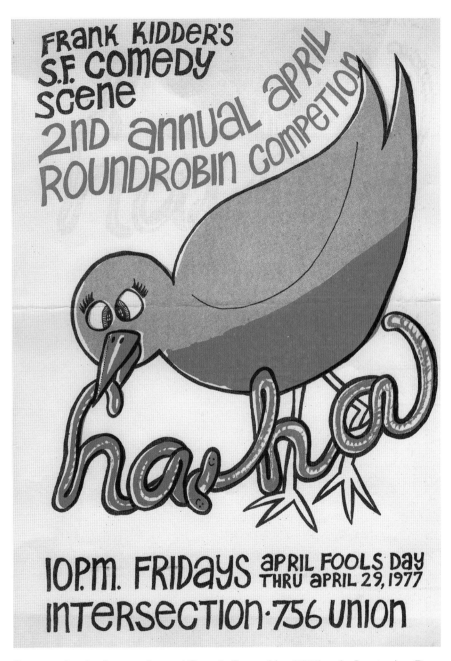

Poster to advertise the second annual Comedy Competition (1977) at the Intersection. Dana Carvey won with less than a year into comedy. *Nina G's collection.*

Kidder was quoted: "Comedy is my life. I'm devoted to it. I'd do anything I can to promote comedy. You can use a sense of humor to communicate with people, to educate them. You can say things through comedy that you can't say to them any other way."

Kidder produced shows while also teaching stand-up. Milt Abel was one of his students. When Abel moved from his hometown in San Jose to San Francisco, Kidder gave him a spot hosting the first night in San Francisco in 1981. Kidder shared with Abel the potential he saw in him. After the first class, Abel was on a non–drug induced comedy high for days after. From 1981 to 1984, Abel performed every night, sometimes five sets a night. Abel eventually competed in the San Francisco International Comedy Competition. In 1984, he came in fourth place. Over ten years later, in 1996, Abel came in third place.

After experimenting with different shows and exercises to help comedians, Frank Kidder started the San Francisco International Comedy Competition in 1976. The first competition awarded the winner $187. Robin Williams came in second place. First place went to Bill Farley. Despite his loss, Williams reflected on Kidder's influence affectionately: "The first time I performed actual stand-up was at [Frank Kidder]'s shows in the Intersection basement....That's where I picked up that anything goes. I guess he was a comic savant; he was always having ideas....But in the beginning, there was Frank Kidder."

Jon and Ann Fox attended a show at the Intersection one night where they saw a line-up of comedians that included Dana Carvey, who they were especially impressed with. Carvey was a student at San Francisco State University. The audience was small. When Jon Fox talked to Kidder about the show and Fox's surprise that there was not more of an audience, Kidder commented, "Yeah, we're having trouble getting the word out.... The newspapers won't even print our listings. I have this idea though to get attention. It's to make the show into a sporting event by doing a comedy competition. I did it last year and I want to do it every year, but I'm having trouble getting things set up again." Coincidentally, Jon and Ann Fox had experience in event planning and publicity thanks to day jobs they held at the time. They had a follow-up meeting with Kidder and his wife, Hilda, cementing their decision to join him for the second San Francisco Comedy Competition. Once Jon and Ann Fox united with Kidder, the winning purse increased to $1,000 for the 1977 competition. In the coming years, the Foxes would operate a new high-end comedy club, the Punch Line. In the summer of 2021, the San Francisco International

Jon and Ann Fox co-produced the San Francisco Comedy Competition alongside Frank Kidder. *Courtesy of Jonathan Fox.*

Comedy Competition ramped up for September, where comedians once again competed for the first time since the 2020 pandemic. Jon Fox remains the executive producer.

Many comedians who won or placed would go on to national and local fame: Bob Sarlatte (fourth place in 1976), Marsha Warfield (first in 1979), Michael Winslow (fourth place in 1979), Will Durst (first in 1983), Mark Pitta (second in 1984), Sinbad (first in 1985), Ellen DeGeneres (second in 1985), Jake Johannsen (first in 1986), Dana Gould (fifth in 1986), Warren Thomas (first in 1987), Tom Kenny (fourth in 1987), Rob Schneider (fifth in 1987), Nick DiPaolo (second in 1990), Matt Weinhold (third in 1990), Louis CK (fifth in 1991), Johnny Steele (first in 1992), Ngaio Bealum (second in 1992), Marc Maron (second in 1993), Patton Oswalt (fifth in 1993), Doug Stanhope (first in 1995), Dane Cook (second in 1995), Ralphie May (fourth in 1998), Joe Klocek (second in 2003), Mike E. Winfield (fourth in 2006),

Maureen Langan (third in 2009), Kabir Singh (first in 2014), Ellis Rodriguez (first in 2017) and Chelsea Bearce (third in 2021).

The contest is considered by many to be the longest-running comedy competition of its kind. Some believe that television shows like *Last Comic Standing* were inspired by it. The annual competition brings comedians through multiple rounds. In recent years, comedians apply to participate by sending a short video clip for consideration to perform in the preliminary round. If the selected, comedians perform at shows held at different venues across the Bay Area and Northern California leading to the finale. There are multiple rounds, with thirty-two comedians doing more time as they advance. In the final round, comedians perform for twelve to fifteen minutes. The variety of cities the competition is held in means comedians' acts must be flexible and well rounded, appealing to diverse audiences in order to have successful sets. Some San Francisco comedians can get stuck in the culture of the city, finding that their references may not be relatable in Antioch or Santa Rosa. It is imperative for comedians to have universal material that reaches everyone. When Myles Weber competed and won first place in 2015, he performed a TV clean set in Rossmore, a retirement community in Contra Costa County and subsequent shows at UC Berkeley, a casino and a venue in Modesto. Ngaio Bealum, who competed multiple times in the 1990s and came in second in 1992, concurs with Weber's analysis: "You can't just have one killer ten minutes that's just going to kill every time because the crowds are always different. So you had to have a variety....You had to have a little willingness or ability to read the room, to see what was going on, to catch the vibe, the surf, the wave." Weber concurs that profiling the audience helps a comedian know how to better connect with them and give the audience what will work for them.

Connecting with the audience is important to a comedian's performance. In fact, it is an element they are judged on. Kidder, in his love of comedy, came up with seven categories in which to rate the comedians. This contrasts with many comedy competitions that award comedians by audience votes, where pure comedic talent may not be enough to win if comedians fill the audience with friends and family who might just vote for them out of loyalty. Although the San Francisco International Comedy Competition considers audience favorites, it is not the backbone of how comedians are judged. Instead, comedians are rated on stage presence, technique, delivery, audience rapport, audience response, material and judges' impression. An additional point can be earned with a "tremendously obvious encore point," which is the reaction of the audience after the

comedian's set. Weber adds that this system, which he has been on both sides of as a competitor and a judge, potentially rewards the artistry of stand-up. Pandering is not necessarily rewarded. Also crowd work, which Weber is known for and skilled in, is too risky because you don't know what the response will be or the subsequent payoff.

As comedians advance, they compete in classier and classier venues. Just because the venue is high-end does not mean that a comedian's set will go as planned. In 1989, Dan St. Paul performed in Davies Symphony Hall, likely the most posh and beautiful place a comedian will ever perform. During his set, the microphone went out. He had to riff until it got fixed. That night he placed in third after Dexter Madison and Oakland native and *Hangin' with Mr. Cooper* star Mark Curry.

The format of three-to-fifteen-minute sets across weeks does not necessarily work for all comedians. Some comedians, because of their act, delivery or material, need more time than just a few minutes to show their comedy chops and connect with an audience. Alex Bennett once commented, "It's a special kind of situation where only certain people shine. Acts that take a long time to build are at a disadvantage when they're given just minutes, which is why a Stephen Wright or a Bob Goldthwait didn't do well."

Not all comedians come with a collegial attitude. Marsha Warfield was the first woman to place in the competition and took first. One comedian who lost to Warfield was quoted in a 1979 *San Francisco Examiner* article complaining, "Marsha Warfield won because a black woman comic would help the Competition this year. They didn't want another…act like mine to win." This particular performer was more physical, in contrast to Warfield's modern stand-up comedy style, with an obvious female perspective. Warfield starred in the long-running TV show *Night Court*, has been nominated for NAACP Image and Soul Train awards and is still active in comedy today, recently coming out of retirement.

Today, the winners are paid thousands of dollars and have one of the most prestigious comedy competition credits. Weber says that it is up to the comedian to make the most out of winning, marketing themselves using the credit. Weber was contacted by *America's Got Talent* to be on the show. He did not have to go through the initial audition and screening. Winning the San Francisco Comedy Competition was enough. Unfortunately, when Weber made it backstage, standing next to Nick Cannon, ready to go on next, the producers said they had to stop the show because they went too long. That's showbiz, folks! Nonetheless, the competition's first-place winner has been able to tour the country making a living at comedy.

Chelsea Bearce performing at round one of the San Francisco Comedy Competition. She went on to take third in the finals. *Nina G's collection.*

Carrie Snow says that the San Francisco Comedy Competition, which she placed in, helped elevate her career in comedy significantly. In a 1991 interview, Snow sums up the competition by saying, "For comics, it is cool to pretend that you don't care about the competition. But it's a very San Francisco tradition. It, along with Comedy Day in the park, means summer in San Francisco has begun."

SAN FRANCISCO COMEDY DAY

The Woodstock of Comedy
—Robert S. Wieder

On November 18, 1978, the world experienced the Jonestown Massacre. It hit San Francisco especially hard because Jim Jones had established the Peoples Temple in the Fillmore District. Then, on November 27, 1978, just nine days later, Dan White shot Harvey Milk and Mayor George Moscone.

Comedy Day in the bandshell in Golden Gate Park. *Photo by and courtesy of Jeannene Hansen.*

Group photo from Comedy Day. Jane Dornacker can be seen in the background on a keyboard. *Photo by and courtesy of Jeannene Hansen.*

Debi Durst reflected on this period, "It was just a heavy, heavy time to be in San Francisco. There was no joy, no nothing. It was just gray. The city was gray…just trying to do comedy…people were just not buying it." After the two events, the city was suffering and grieving.

Thinking about how to bring some relief to the city, led by Jose Simón, Rebecca Spencer (manager of the Holy City Zoo) and John Cantu (owner of the Holy City Zoo), the idea for Comedy Day in Golden Gate Park was hatched. In 1981, the first Comedy Day happened on the bandshell stage with two thousand people in attendance. Year after year, the event grew bigger and bigger. Comedy Day swelled, forced to move to the Polo Fields next, followed by Sharon Meadow (later to be renamed), where it resides today. The *San Francisco Chronicle* sponsored the event for several years. Durst still considers it San Francisco stand-up comedy's "company picnic." There were sixty thousand in attendance at its peak. Regarding Comedy Day's size, Larry "Bubbles" Brown in 1983 told the *San Francisco Examiner*, "It was terrifying and fun. Not unlike sex."

As fun as the show was on stage and in the audience, the real party was backstage. All of San Francisco comedy, including bookers, reporters, as well as comedians, were there. There was a green room for the more

The sheet cake bearing the names of all the comics who performed. *Photo by and courtesy of Jeannene Hansen.*

Michael D. Booker performing at Comedy Day at its height. *Courtesy of Michael D. Booker.*

prominent comedians while lesser-known comedians from all of Bay Area comedy's echelon were able to hobnob, eat and drink for free. Because the *Chronicle* sponsored the event, comedians would also have their names plastered on the back page of the Sunday edition, which helped build their credibility in the Bay.

For many, performing at Comedy Day was a marker of truly being part of the San Francisco comedy community. Tom Ammiano started comedy when he was forty years old. His home base was at the Valencia Rose, a place where queer comedians could be open about their sexuality as well as physically safe from the homophobia that many felt in mainstream comedy clubs. As Ammiano tells it in his book *Kiss My Gay Ass*, Simón had been checking out comedians like Marga Gomez and Monica Palacios at the Valencia Rose when Ammiano was invited to perform at Comedy Day. In an interview with the authors, Ammiano said, "[Simón] saw a bunch of us and he liked us and he came up later and he said, 'I don't care about anybody being gay, if you're funny, you're fucking funny.' So we started getting invited to Comedy Day, which really then was wow!" Ammiano went on to add, "It was at the bandshell in Golden Gate Park....It was a couple thousand fucking people. I mean, I nearly shit my pants!" Ammiano was the first "out" gay comedian to perform at Comedy Day. Ammiano was asked back to perform the year after and remains on the board for Comedy Day today.

Throughout the years, comedians who got their start in San Francisco returned to perform in Golden Gate Park. At any given Comedy Day, you

Diane Amos and Michael D. Booker. *Courtesy of Michael D. Booker.*

Jose Simón looking up to Pat Morita at Comedy Day. *Photo by and courtesy of Jeannene Hansen.*

Robin Williams and Rick Overton on stage at Comedy Day. *Photo by and courtesy of DNA.*

might see Margaret Cho, Kevin Meaney, Dana Gould, Paula Poundstone, Don Novello as Father Guido Sarducci, Bobcat Goldthwait and of course, Robin Williams. After Williams's death in 2014, Comedy Day memorialized him. Sharon Meadow, where Comedy Day was held in its most recent years, was renamed Robin Williams Meadow. Throughout the day, one could see comedians like Margaret Cho donning rainbow suspenders in his remembrance. A massive photo of Williams performing at Comedy Day with the words "In Loving Memory" was the backdrop of the stage. The day ended as a memorial to him. Through community and humor, Comedy Day returned to its origins of providing a release for the pain that San Francisco was experiencing with the death of their beloved son.

Debi Durst has organized Comedy Day the past few years, doing everything from organizing permits and applying for grants to advising on where to put dumpsters. Comedy Day remains a centerpiece in Bay Area Comedy with many comedians on the board. The year 2020 was supposed to be the fortieth anniversary of Comedy Day. Because of the pandemic, it did not happen the last Sunday of the summer of 2020, as usually scheduled. Comedy Day instead returned on September 19, 2021, for its

Opposite, top: Group photo of Tim Jackson, Mark Curry, Michael D. Booker, Warren Thomas, Al Clethen and David Alan Moss. *Courtesy of Michael D. Booker.*

Opposite, bottom: Will Durst performing at Comedy Day. *Photo by and courtesy DNA.*

Above: Paula Poundstone performing at Comedy Day in 2021. *Photo by Nina G.*

fortieth anniversary, featuring local favorites and homegrown stars like Paula Poundstone, Diane Amos, Johnny Steele and Larry "Bubbles" Brown (as well as one of the authors of this book). As San Francisco recovers from economic and emotional hardships inflicted by the pandemic, Comedy Day returned once again in the tradition of alleviating the city's troubles with much-needed COVID-19-safe comedy in Robin Williams Meadow.

6

QUEER COMEDY

With all due respect to the revolutionary Stonewallers of New York City, it was at the Valencia Rose and later Josie's Juice Joint and Cabaret in the Castro that spawned the gayest group of comics.
—Karen Williams

Queer humor is nothing new. Humorists like Oscar Wilde have made themselves known for years, but the modern form of stand-up comedy did not immediately embrace comedians who were lesbian, gay, bisexual or transgender (LGBT). The first openly queer comedian on TV was Robin Tyler in 1979. Her Showtime appearance on the *First Annual Women's Comic Show* was introduced by Phyllis Diller, where she told the following joke:

Tyler imitating the voice of a man shouting at her: "Hey, are you a lesbian?"

Tyler as herself: "Hey, are you the alternative?"

As groundbreaking as Tyler's performance on the early cable special was, few queer comedians immediately followed. There were comedians who were gay, lesbian and bisexual performing in the Bay Area, but they were not *out*. When they talked about a romantic partner in their act, they would use the opposite sex gender and not broach the subject of their sexual orientation. Many Bay Area comedians made an impact on American society and the world coming out of the closet in later years. Ellen DeGeneres, who famously came out on her self-titled sitcom on April

Robin Tyler Takes the Stage *at the Valencia Rose*

Friday & Saturday, Oct 21 & 22 8pm $6 766 Valencia Reservations: 863-3863

Robin Tyler flyer for the Valencia Rose. *Courtesy of Gay, Lesbian, Bisexual, Transgender Historical Society, Donald Montwill Collection.*

30, 1997, developed her act in San Francisco in the early and mid-1980s. DeGeneres's early stand-up was observational and excluded any romantic or cultural experiences as a lesbian. This was common for many queer comedians until a politically active special education teacher from New Jersey stepped onto a San Francisco stage. His name was Tom Ammiano, the "mother of gay comedy."

Ammiano first started stand-up in the early 1980s when he was forty years old. His first attempt at stand-up was at a local San Francisco open mic, where he was met with homophobic responses from the audience. Homophobia was common in the culture of the 1980s, and the material of many comedians was no exception. Ammiano stood out as one of the few openly gay comedians in the mid-1980s. The hostility from both the audience and the comics kept him from performing in mainstream clubs despite his lifelong love of comedy and his propensity to be funny. Ammiano would go on to help create a home for gay comedy at the Valencia Rose.

The Valencia Rose was a cabaret converted from a mortuary on Valencia, the street that bridged the Castro with the Mission. At the time, the Castro

Tom Ammiano, the father of gay comedy, performing at San Francisco Comedy Day in 2021. *Nina G's collection.*

was what Ammiano classified as "dickcentric," or predominately male. The Valencia Rose would have a mix of the queer community, whereas other bars were predominately gay or lesbian but not both. When Ron Lanza and Hank Wilson opened the Valencia Rose in 1982, Ammiano approached

them about having a "gay comedy night." They asked him what *gay comedy* was. Ammiano admitted, "I don't know. All I know is I go to straight comedy clubs and I try to be funny and I talk about being gay and they want to eat my liver! I need a place to develop." With the help of Ammiano and comedian Carol Roberts of Femprov, the Valencia Rose transformed from a mortuary to a cabaret and birthed the room considered to be the first of its kind featuring gay comedians. Ammiano hosted a Sunday open mic for people who wanted to try their hand at comedy and others who wanted to work on their acts in a place where they felt safe, performing to an audience that embraced a queer perspective. A Saturday showcase soon followed with more professional and polished comedians in the lineup. The Valencia Rose (and later Josie's Juice Joint) would provide a venue for gay comedy, fostering the talents of queer and queer-friendly comedians like Marga Gomez, Karen Ripley, Karen Williams, Scott Capurro, Monica Palacios, Lisa Geduldig, Whoopi Goldberg and *Orange Is the New Black*'s Lea DeLaria, just to name a few.

There was a sensibility to the comedy, entertainment and cabaret environment that the Valencia Rose fostered. Not all the performers were LGBT or queer themselves. Marga Gomez emphasized that "[the Valencia Rose] wasn't really about who you were as a performer. It's more like what does our LGBT audience want? Is this respectful to our audience? Is this not racist, not homophobic, not sexist, all those things, because this was an audience that was, uh, very much about intersectionality before we even knew the term." As a result, there were many comedians, mostly female, who could drift from mainstream clubs and find stage time and audiences at the Valencia Rose. Donald Montwill booked many of the shows. Regarding the curation of stand-up, Gomez went on to add, "His vision [for comedy] was it's not about who you go to bed with. It's about your relationship to the status quo. If you're really a rebel, if you're really radical, then you know, you're not putting forth heteronormative structures and edicts…that was the essence." Montwill, in his own words, summed it up as "I don't want to run a club where after a night of comedy someone leaves with pain. I want my audience to feel like they are safe from attack for an hour and a half."

Whoopi Goldberg and Jane Dornacker were two comedians whose work was curated by Montwill and the staff of the Valencia Rose. Goldberg was based in Berkeley with the Hawkeye Theater. She often appeared at the Valencia Rose with her improv partner and at other venues performing her one-person shows, including her portrayal of Moms Mabley and the development of *The Spook Show*, which led to her performances on

GAY COMEDY OPEN MIKE
with co-emcees Tom Ammiano & Lea DeLaria
EVERY MONDAY 8:30 PM $3
Performer sign-up at 7:30 PM

Photo by Greg Day

GAY COMEDY NIGHT
with alternative emcees Lea DeLaria & Tom Ammiano
EVERY SATURDAY 10 PM $4

VALENCIA ROSE 766 Valencia (betw 18th & 19th)
Reservations: 863-3863

Gay Comedy night hosted by Tom Ammiano and Lea Delaria. *Courtesy of Gay, Lesbian, Bisexual, Transgender Historical Society, Donald Montwill Collection.*

Left: Flyer for Whoopi Goldberg's "Farewell Show" at the Valencia Rose. *Courtesy of Gay, Lesbian, Bisexual, Transgender Historical Society, Donald Montwill Collection.*

Right: Flyer for Whoopi Goldberg's one-person show based on Moms Mabley. *Courtesy of Gay, Lesbian, Bisexual, Transgender Historical Society, Donald Montwill Collection.*

Broadway in New York City. In a 2020 interview with Howard Stern, Goldberg said that Alice Walker saw her in San Francisco. Walker then encouraged Steven Spielberg to see her show. Spielberg was not able to get to New York in time for her performance, so he invited Goldberg to his home in Los Angeles to perform for him, his friends Quincy Jones and Michael Jackson, as well as other well-knowns in the audience. From there she was cast in Spielberg's movie *The Color Purple* for which she was nominated for an Oscar. She did not win that year, but she did a few years later for her supporting role in *Ghost*.

Jane Dornacker's performance persona is just one example of the comedy that embodied the rebellion and radicalism that Gomez talked about. Dornacker easily flowed from mainstream nightclubs to venues like the Valencia Rose. Dornacker was a native of Albuquerque before coming to the Bay Area to attend San Francisco State University. She gravitated to the alternative scenes in San Francisco, first hippie and then punk. Dornacker wrote and performed with the musical group the Tubes. She also led the band Leila and the Snakes as the aforementioned "Leila" before she ventured into comedy. Dornacker was 6'4", redheaded and

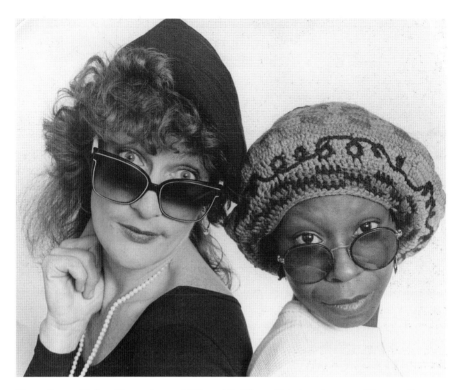

Photo shoot with Jane Dornacker and Whoopi Goldberg. *Photo by and courtesy of Jeannene Hansen.*

buxom. Her talent and strong stage presence engaged audiences across many demographics. Her popularity grew when she became the funny traffic reporter for the popular morning radio show on KFRC with Bay Area icon Dr. Donald D. Rose. In fact, she became so accomplished in her role as the traffic reporter that she eventually moved to the larger market in New York, where she was a traffic reporter at WNBC. Tragically, Dornacker died in a helicopter crash while on the job on October 22, 1986. Many of the comedians interviewed for this book remember her fondly.

The Valencia Rose closed in late 1985, but the spirit of the club did not. Josie's Juice Joint opened in the Castro District at the former building of the Able Pen Company. Wilson and Lanza gutted the building to make a new home for what one writer for the *San Francisco Chronicle* called "the hungry i of homosexual humor." Much like how Mort Sahl developed a new style of comedy, the comedians of the Valencia Rose and Josie's Juice Joint were able to write, perform and negotiate their queer and

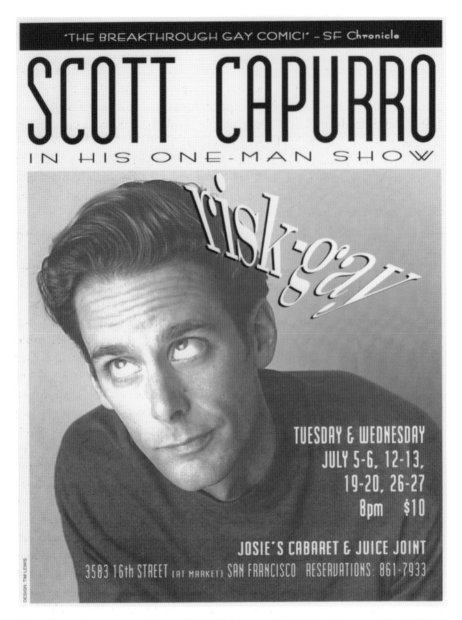

Scott Capurro's one-person show at Josie's Cabaret and Juice Joint. *Courtesy of Gay, Lesbian, Bisexual, Transgender Historical Society, Ron Lanza Collection of Josie's Cabaret and Juice Joint.*

comedic identities in a place that was primed to understand and laugh with their experiences.

The comedy that came out of the Valencia Rose and Josie's had an impact nationally. Lea DeLaria was the first openly queer comedian to perform on a late-night talk show with her appearance on *The Arsenio Hall Show* in 1993. Hall introduced her: "Some people think that my next guest is too controversial for TV. She's a lesbian stand-up comedian. But when do I care about what *some people* think? I invited her here tonight because of what she does standing up, not what she does laying down." DeLaria was met with cheers and fist-pumping woofs made famous by Hall's Dog Pound cheering section of his audience. She killed, but the network's lawyer objected to showing the performance because DeLaria said *dyke*, *fag* and *queer* too many times. Hall fought for the DeLaria segment to air. And it did.

DeLaria and other comedians who came out of the Valencia Rose and Josie's also appeared on Comedy Central's first all-queer comedy show, *Out There*. The comedy showcase was filmed at the Great American Music Hall on National Coming Out Day and television debuted San Francisco legend Marga Gomez, among others. Gomez moved to San Francisco from Manhattan, where she grew up. She is a second-generation comedian. Her father was a comedian performing in Spanish-language venues, and her mom was a dancer. As the only child of the couple, once she moved to San Francisco, she started following in her father's footsteps. Originally wanting to be a writer, Gomez became immersed in the alternative art scene in San Francisco and gravitated toward doing open mics around the city. Gomez was openly a lesbian in her personal life but not on stage until she found the Valencia Rose, where all that changed. She discovered that muting herself on stage, along with being uncomfortable in an environment that wasn't queer and Latino friendly, resulted in her not doing well in many heterosexual comedy venues. "I was sort of dabbling with being in the closet," Gomez explained, "but then when I went to this place and I did ten minutes at their open mic and for an audience that was out [of the closet] or allies. I realized I don't want to censor or edit anything about myself. And I discovered that my performance style is very personal. I mean, you know, yes, I'm a lesbian. Yes, I'm Latino, but I'm neurotic first." Gomez went on to add, "That's basically how it started. My love of comedy, the influence of my father, and then being in San Francisco at the right time."

Gomez went on to national exposure, which included *Comic Relief VI*, where she was warmly introduced by Robin Williams. She has remained exclusively a comedian and performer but has not always maintained a

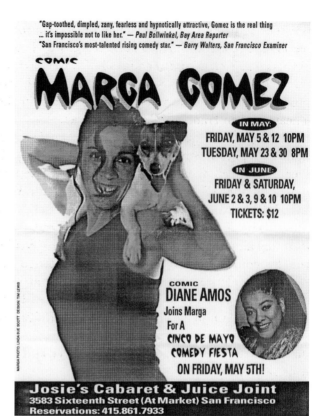

Right: Flyer for Marga Gomez and Diane Amos at Josie's Juice Joint. *Courtesy of Gay, Lesbian, Bisexual, Transgender Historical Society, Ron Lanza Collection of Josie's Cabaret and Juice Joint.*

Below: Marga Gomez performing at Comedy Day. *Photo by and courtesy of DNA.*

presence at the more mainstream San Francisco comedy clubs. Instead, she has found an audience in the Latino, feminist and queer communities of San Francisco, as well as toured nationally. Gomez has produced and performed multiple one-woman shows, as well as fostered talents of new comedians by producing showcases at venues like the Marsh in Berkeley and the Brava Theater in San Francisco's Mission District.

The legacy of queer comedy that Ammiano and Gomez played a significant part in continues in the Bay Area today. Throughout the years, there have been open mics and showcases at popular LGBT venues like the Stud, the SF Eagle, Eros and Oakland's White Horse. Although LGBT friendly, many of these shows were not exclusively queer comedy shows. The one exception is Hysteria. Hysteria is a current open mic featuring almost exclusively queer and female-identifying comics currently run by comedian Wonder Dave. Dave started stand-up in the early 2010s after performing in improv and sketch performances. The first time he performed at an open mic was in San Francisco. Much like the homophobia Ammiano encountered in the 1980s, before he was called up to the mic, another comedian used the word *fag*. Dave proceeded to give the comic shit that night when he performed and continues to do so when necessary today.

Dave was not the first host of Hysteria. The show was started by comedians Irene Tu and Jessica Sele. After a few changes in hosts, Dave maintained the monthly open mic at Martini's on Market Street, on the outskirts of the Castro District. During the COVID-19 pandemic and shelter-in-place, Hysteria went online, maintaining the same schedule. Much like the Valencia Rose and Josie's Juice Joint, Hysteria provides a space for queer and female-identifying comedians to develop their comedic voice. The open mic includes a featured comedian who is an out-of-towner or a dedicated Hysteria performer, often the first time a comedian is highlighted and a sign that they are moving up in the comedy world. Dave says Hysteria provides a space for comedians to discover who they are as performers and learn how to navigate their gender or queerness. The show allows for the experimentation and exploration of topics that might not be received in the same way in a mainstream club.

Dave adds that it is important for comedians to have a good base to test their material, as well as their on-stage persona, to prepare for audiences that don't reflect their experiences. Dave asserts that San Francisco comedy is changed for the better because of queer comedians who are on shows across the Bay Area. As straight male comedians encounter lesbian,

Loren Kraut performs at clubs across the Bay Area today. *Photo by and courtesy of Shawn Robbins.*

gay, transgender and bisexual comedians, they are more comfortable in interactions and less comfortable making them the butt of jokes. Slowly but surely, there have been improvements in mainstream comedy since Ammiano first was heckled, but the homophobia still exists, even in what many perceive as the bastion of liberalism in San Francisco. Nonetheless, spaces like the ones Ammiano created are essential to the advancement of the queer-identifying comedian.

7

BAY AREA BLACK COMEDY RENAISSANCE

The Black comedy renaissance of the late '80s and '90s had seeds and influences from the Chitlin Circuit and party records to hip-hop music and culture. It was a culmination of eons of world history; show business battles; the mainstream success of vanguards like Moms Mabley, Richard Pryor and Eddie Murphy; and wholly invented forms of art and entertainment. Television shows like *Def Comedy Jam* and *In Living Color* and movies like *Friday* turned a new crop of talent into household names. But those stars built themselves up from the ground level performing at venues like All Jokes Aside and the Cotton Club in Chicago, the Uptown Comedy Club and Manhattan Proper in New York and the Comedy Act Theater and Birdland West in Los Angeles.

In many ways, in many eras, San Francisco Bay Area stand-up and improv echo the national conversation regarding comedy and culture. In other ways, with a regional flavor and style, it defines the question, the answer and everything in between.

Just as with late '80s–'90s rap from Oakland, Vacaville and San Francisco, distinct in its sounds, slang and subject manner, the Bay Area Black comedy scene was unlike any other in the country. There was a mix of competition and opportunity, a regional, collective resourcefulness and a nearby network of other Black comedy shows and performers in Los Angeles. Local talent cut their teeth and gained a following as actors, radio broadcasters and television hosts. Soul Beat, the country's only Black-owned television network in 1980s–90s, stood out as a favorite, for performers and audiences alike, to connect with what was going on.

Right: Martin Lawrence performs at the Other Cafe, Emeryville. *Courtesy of Bob Ayres*.

Below: The Godfather of San Francisco Comedy, Tony Sparks, onstage at Comedy Day. *Courtesy of DNA*.

Dorsey's Locker, Tyrone's and Clem Daniel's End Zone in Oakland; Pepperbelly's in Fairfield; Kimball's East in Emeryville; the Englander Pub in San Leandro; as well as Tommy T's (also in San Leandro) with locations later in Pleasanton, Concord and Oakland, were good rooms for hard lessons. While San Francisco's predominantly white comedy audiences were considered "theater-goers," nurturing more absurd and abstract performers, audiences at Black comedy shows commanded and demanded respect. Comedy was a utility. It wasn't precious. If the material was not working, if a comedian wasn't entertaining, the audience would turn. If something disrupted the performance, it was expected to be dealt with by the performer, fast and funny.

In a 2018 episode of the *Industry Standard w/Barry Katz* podcast, Oakland native Marcus King, a producer and early manager for Mark Curry and Jamie Foxx, reflected, "At that time, Black people didn't know what a comedy show really was." Building an audience required strategy, coordination and calling in a whole lot of favors. According to popular Bay Area comedy host Tony Sparks, comedians would promote their shows to strangers on the street, using word of mouth and gift of gab to bring in their audiences. King marketed heavily toward women because "women wanted a release, wanted a chance to laugh." And, conversely, appealing to women attracted male audience members who were also interested in appealing to women.

Doing stand-up in the emergent Black comedy clubs was akin to a civic duty: part crowd control, part community leader. Luenell once broke up a fight at Dorsey's Locker from the stage, according to journalist Rachel Swan. Comedian Donald Lacy recalls going on a tirade about the Oakland Raiders with, unbeknownst to Lacy, two Raiders in the audience. The threat of an altercation sometimes loomed. But if you can consistently say something funny about something in the room, handle hecklers and show confidence and bravado, you become a legend.

Winning the Bay Area Black Comedy Competition was another path to stand-up immortality. "The Bay Area Black," established in 1987, was the premier showcase for comedians all around the world. The multiday event was patterned after the San Francisco International Comedy Competition. Preliminary rounds were held at satellite venues like the Yerba Center for the Arts or Tommy T's. The finals were hosted at the Paramount Theater in Oakland. Oakland native Mark Curry won the competition in 1988. Jamie Foxx earned top honors in 1991. Don "D.C." Curry took the crown in 1995. Other standout alumni of the Bay Area Black Comedy Competition include comedy superstars such as Sherri Shepherd, D. L. Hughley and Chris Tucker.

Picture taken at the Englander in San Leandro in 2009 featuring Del Van Dyke, Dana Garrett, David Alan Moss, Michael D. Booker, Donald Lacy, Norman Hazzard and Frank Ergas. Autographed from each comedian. *Courtesy of Michael D. Booker.*

"I was robbed in '93," lamented Donald Lacy. "The five finalists [were] Anthony 'AJ' Johnson, Sheryl Underwood, Alex Thomas, me and Geoff Brown....And I came in second. When they announced [Brown] as the winner...people were booing. It was almost a riot because my set killed from beginning to end. [Brown] was bombing and then he did this great opera bit."

Still, for all of the success and acclaim they achieved, Black comedians consistently fought for legitimacy within the greater San Francisco comedy scene. Rey Booker's civil rights lawsuit discussions with a Berkeley law firm about accused racial discrimination by some Bay Area clubs were covered by Robert Wieder in the *San Francisco Chronicle*. "People ask me why I don't play those clubs. I don't know! I don't want to say it's racism, but I think it is," claimed Booker. Other Black comedians echoed the sentiment. They expressed their frustration of what they felt was a biased sense of humor and a lack of communication in the booking process.

"They book who they feel comfortable with, the Clarence Thomases of mirth," the *Chronicle* quoted Warren Thomas.

Michael D. Booker, Rey Booker and David Alan Moss backstage at Comedy Day. *Courtesy of Michael D. Booker*.

Warren Thomas at the Holy City Zoo. *Photo by and courtesy of Jim Owens*.

The bookers and some comedians went on record that a recession and a need to promote "proven drawing power" were more of a factor in not booking talent, white and Black alike.

Black comedians' success in non-mainstream arenas may have been a factor. The rise of "urban comedy" coincided with the decline and shuttering of many comedy clubs in San Francisco. This bred resentment from some white comedians toward their Black peers, according to Sparks. Additionally, many accomplished comedians were expected to "pay their dues" to perform at high-end comedy clubs.

"They used to make the comics back in those days wait tables, you know?" recalled Lacy about a confrontation with a manager at a well-known Bay Area club. "I said, 'Dude, I'm here to tell jokes...I'm from Oakland, man. You're either gonna put me up or you ain't....But I'll be damned if I'm going to be a busboy up in here.'"

Despite their ability to perform and the audience they could attract, a number of Black comedians weren't given work (or access to gatekeepers) available through mainstream venues.

A few comedians could navigate both spaces. Thomas, an African American comedian, was a favorite of the Holy City Zoo and the Punch Line San Francisco. He also performed on BET's *Comic View*. Comedian Bobby Slayton, a Jewish American comedian, also a favorite of the Holy City Zoo and Punch Line San Francisco, killed at Showtime at the Apollo. Standouts from a number of different ethnic groups developed their careers in the Bay Area by appealing to who would book them and which audiences they attracted. But the greater comedy infrastructure remained largely segregated.

8

THE NEW MILLENNIUM

And then there were two. After the closing of numerous comedy clubs, only Cobb's Comedy Club and Punch Line Comedy Club remained in San Francisco. But for a time, there was only one.

In 1987, Cobb's Comedy Club relocated to the Cannery building in Fisherman's Wharf. The club provided a destination to see new and established comedians for San Francisco's date night and tourist fare. That is, of course, until March 17, 2002, when a fire erupted at developments near the Cannery. Cobb's was flooded. Legal trouble, eviction and unseemly elements related to the destruction and reconstruction surrounding the building pushed the club and its owner to the brink.

Sawyer moved the club to Columbus Ave in North Beach, a two-block area rich with comedy history. The Boarding House relocated to 901 Columbus Ave in 1982 and closed in 1983. The neighboring Bimbo's 365 Club hosted comedy from time to time throughout the decades with the likes of Rodney Dangerfield and Sid Caesar. A full-time comedy club was a different story.

Comedians volunteered to help complete the venue's renovation. They tore down and cleaned out the former music venue for a seven-hundred-person-capacity comedy theater. Anonymous benefactors helped with financial investment. The group effort allowed Cobb's Comedy Club to reopen in November 2003.

Still, San Francisco show business presented difficulties. In addition to all the increasingly enticing entertainment options at home, online and elsewhere in the city, Cobb's was operating in a time very different from the era it was established in. "There's virtually no support," Sawyer lamented

about the local media. After fighting long and valiantly, Tom Sawyer eventually sold Cobb's Comedy Club in 2005 to Live Nation. Cobb's was the last independent all-comedy club in San Francisco.

An entertainment giant buying Cobb's Comedy Club proved to be emblematic. Corporate interests consolidated and controlled most of the comedy infrastructure in the area. Radio and large ticketing companies filled arenas and amphitheaters with nationally touring comedians on supershows and festivals. Television broadcasters and recording companies continued to use San Francisco as a backdrop for comedy specials and albums, a tradition dating back to the 1960s. San Jose renovated its historic Jose Theatre at the turn of the century; an Improv comedy club franchise opened there in 2002.

Smaller clubs kept comedy alive in the suburbs. Rooster T. Feathers remained in Sunnyvale. Tommy T's in Pleasanton was the last East Bay comedy club standing.

Regular gigs were sparse for local comedians. Attention from local publications even more so. The Bay Area tradition of developing and recognizing talent persisted. Great comedians continued to get their start, to grow. The showrunners, bookers and producers identify and foster those talents. Comedians like the hilarious and hustling Ali Wong, the sharp and acerbic Kaseem Bentley and the left-champion contrarian Nato Green put their stamp on the city. Their success, and that of many others, provided a blueprint, a roadmap, to what it meant to be a quintessential "San Francisco comedian" in the twenty-first century.

FROM HERE

A comedian born and raised in the Bay Area and their relationship to Bay Area comedy could span from the profound to the trivial. The region's culture and energy leave an indelible mark on its homegrown residents. Those residents can, in turn, leave a mark on the area's comedy history. But the results of that exchange are often varied and intricate. There's no greater triumvirate for the many ways a native can be a "Bay Area comedian" than Chelsea Peretti, Andy Samberg and Moshe Kasher.

Oakland's Peretti is the bridge; she grew up with Samberg and was a friend of Kasher as well. She later relocated to New York as a young adult, eventually becoming a renowned stand-up comedian, actor and musician. She filmed her 2014 special *One of the Greats* at the Palace of Fine Arts in San Francisco.

Moshe Kasher credits Peretti for helping his introduction to stand-up. Staying close to home for a time, Kasher established himself as a respected comedian, writer and actor. Kasher was crowned a 2007 "Best of the Bay" by the *East Bay Express*, vaunted for projects like the sketch group Boomtime and the live comedy showcase Smug Shift. His 2012 special, *Live in Oakland*, was filmed at the New Parish in the Town's Downtown District. His memoir, *Kasher in the Rye*, also released in 2012, detailed experiences with addiction, religion, Deaf culture and race while growing up in those same Oakland streets.

In 2013, Chelsea Peretti's path would cross professionally with Andy Samberg on the hit television sitcom *Brooklyn 99*. Samberg started his comedy career in Los Angeles alongside friends and fellow Berkeley natives Jorma Taccone and Akiva Schaffer. The trio, known collectively as the Lonely Island, found notoriety with video sketches before eventually working together at *Saturday Night Live*. Their "SNL Digital Shorts," specifically their comedic music anthems (as the Lonely Island), were the calling card for careers that included albums, movies and television. They often collaborated with local icons, like Oakland rapper Too Short, or paid homage to regional culture, like in *The Unauthorized Bash Brothers Experience*. Their first official concert as the Lonely Island took place on June 1, 2018, at the Clusterfest Comedy Festival in San Francisco's Civic Center Plaza, right outside the steps of City Hall.

San Francisco also kept its Golden Gates open to transplants attracted to its unique offerings and allowances. Before the serene observationalist Sheng Wang became a reputable, national headliner, he originally settled in the Bay for school, UC Berkeley to be exact. World-trotting Will Franken found refuge in San Francisco for a time. Jazz-talky Jasper Redd was inspired to move from Tennessee to San Francisco after listening to all the comedy albums recorded in the Bay Area.

W. Kamau Bell embodied the appeal and ideal of moving to San Francisco and becoming one of its best comedians. After starting in his native Chicago, Bell progressed and impressed as one of the nation's most hilarious political and social commentators. He was originally just a "really good" comic: he worked regularly at the local SF comedy clubs, hosted the Siskel and Negro radio show on Live 105 with fellow comedian Kevin Avery, released his album *One Night Only*, performed on Comedy Central's *Premium Blend*, all while calling San Francisco Bay Area home. He's widely credited with the first Barack Obama joke. The year 2007 marked an inflection point in Bell's career, the year he launched his one man show, the *W. Kamau Bell Curve: Ending Racism in About an Hour*.

W. Kamau Bell performs at the Punch Line San Francisco. *Photo by and courtesy of Shawn Robbins.*

San Francisco's relationship with "edutainment" and one-person shows can't be overlooked. Akin to Mort Sahl, Phyllis Diller and Lenny Bruce changing ideals and attitudes from North Beach nightclubs, San Francisco's comedic alumni, and their brand of political satire, have always had a home on the airwaves. Emmy-winning *The Smothers Brothers Comedy Hour* (1967–69) was a watershed in television on and off screen, as Tom and Dick Smothers fought for free speech and artistic control against CBS, their broadcasting network. A. Whitney Brown, Jim Earl and Vernon Chatman, veterans of the '80s and '90s San Francisco comedy scenes, all contributed to late-night comedy with their work on *Saturday Night Live*, *The Daily Show* and *The Chris Rock Show*, respectively. Al Madrigal (SF90s) and Hasan Minhaj (SF00s) were on-screen correspondents of *The Daily Show* at the same time—their tenures both bridged the Jon Stewart and Trevor Noah eras. Minhaj later wrote, produced and hosted his own satirical and illuminating show *The Patriot Act with Hasan Minhaj*.

SF comedians naturally have their own unique tones and perspectives. And when marrying that voice with narrative, they've had a noteworthy and successful symbiosis with theater. Margaret Cho's *I'm the One That I Want*, filmed at the Warfield Theater, was a one-woman show concert film that helped the San Francisco native contextualize her career and redefine her

trajectory. Joan Rivers chose to workshop her one-woman show, *Joan Rivers Theater Project*, at San Francisco's Magic Theater. Marga Gomez (*Intimate Details, Pound*), Brian Copeland (*Not a Genuine Black Man*), Rob Becker (*Defending the Caveman*), Rick Reynolds (*Only the Truth Is Funny*), Zahra Noorbakhsh (*All Atheists Are Muslim*) and Donald Lacy (*ColorStruck*) were all veterans of both stand-up and solo play theater. Whoopi Goldberg's development of *The Spook Show* at the 2019 Blake St Theater in Berkeley, California, to her run at the Dance Theater Workshop in New York (and beyond), was the pinnacle of this relationship.

W. Kamau Bell Curve married those two informational and introspective traditions into a cogent and lauded mixture of social commentary, multimedia and humor. Bell also played with conventions of the theater experience itself, offering two-for-one tickets for people who brought someone of a different race to the show. A local success, the show toured to Los Angeles and New York, eventually attracting the attention of stand-up comedian and producer Chris Rock. Bell, Rock and others would collaborate to produce *Totally Biased with W. Kamau Bell*, a sociopolitical variety show from Bell's perspective, launched in 2012. The show was rare for its diversity, raw discussions and for being one of the few shows in late-night television history hosted by a Black comedian. *Totally Biased* also employed several performers with Bay Area roots as writers and performers such as Kevin Kataoka, Guy Branum, Janine Brito, Nato Green and Kevin Avery. The weekly show was upped to four times a week before being canceled in 2013. After a brief stint in New York City for the show, Bell followed up *Totally Biased* with the travel documentary series *United Shades of America*, a book and comedy specials, all while retaining his residency in the East Bay.

Like Bell, some San Francisco comedians were able to retain or expand their comedy enterprise from the City by the Bay. But many comics eventually moved to advance their careers in cities like Los Angeles and New York City.

Dot Com

The bulk of San Francisco comedy became largely independent by necessity. Open mic nights maintained the scene, a refuge for comedians. And if you did comedy in San Francisco at the turn of the millennium, you knew Tony Sparks.

Tony Sparks, affectionately known as "The Godfather of San Francisco Comedy," hosted the open mic at Brainwash Cafe for over eighteen

Tony Sparks addresses comedians before they perform at the Brainwash open mic. *Courtesy of Anthony Medina.*

years. The inaugural edition occurred Thursday, April Fool's Day 1999. Brainwash, an internet café and laundromat in the San Francisco South of Market District, was an epicenter of activity every Thursday. The line to sign up started in the afternoon, snaking along the side of the building for comedians to get three to five minutes of stage time. Comedy would last until 10:00 p.m., closing time. The Brainwash open mic attracted anyone from a person looking for their first set, to an established veteran, to a performance artist, to a national headliner, all performing to an audience that oscillated between engrossed, apathetic or absent. Besides Tony, the staff and a few choice regulars, everybody who attended filtered in and out throughout the night. And whether a comedian would have the set of their lives or flounder painfully, if somebody was performing for the first time at the Brainwash, they would be introduced to the room the same way.

"Your next comic is new to the room. So that means we give them..." Spark would preamble. "A LOT OF LOVE!" the other comedians and audience would respond in unison. "Everybody!" Tony would implore. "A LOT OF LOVE!" the room would reiterate, louder.

Comedians would wait in line for hours for a few minutes of stage time at the Brainwash. *Courtesy of Anthony Media.*

The explosion of enthusiasm would carry many newcomers to a decent (or surprisingly good) first time. Return engagements offered a lot less fanfare. But by then, a performer would know if they had a hunger for the stage and branch out to the numerous open mics across the Bay Area. The Brainwash was a rite of passage. It was also home to other hosts and events. Wednesdays at the Brainwash was the Ladies Night open mic. Hosts Kristee Ono and Caitlin Gill spearheaded inventive themed nights like "Gown Night" and "Spring Fling," where performers would dress up in formal wear and finery.

The influence Tony Sparks had was undeniable. Along with producer Kiko Briez, Sparks also hosted and helmed weekend showcases throughout

San Francisco, at neighborhood bars like Il Pirata in Potrero Hill and 7 Mile House in Bayshore. If a newer comedian impressed at the Brainwash, if Tony or someone Tony trusted saw potential, the upstart may be invited to perform there. Tony Sparks's showcases were electric and eclectic, a party-like environment. The variety of styles, identities and points of view, newer comedians and veterans, diverse lineups and audiences, melded everything San Francisco had to offer. Whether you were a regular performer at the Punch Line, or a local pariah, the door could be opened. And Tony Sparks held the keys.

Sparks wasn't the only one.

"I went to the Brainwash one time, and I said to myself, 'There are too many people here,'" recounted Pete Munoz.

Bay Area comedy at the turn of the century was often made of microscenes. Partly due to a comedian's identity and the audience they attracted, as well as tastes and aesthetics that filter through race, gender, gender expression, sexual orientation and comedy style, the vibe could be different from region to region. North Bay skewed older. East Bay boasted bravado. Munoz, a fixture of the South Bay comedy scene, characterized his slice of the Bay as friendly and close-knit.

"I've had people come from San Francisco by themselves and say, 'I love the South Bay because you come by yourself and right away you're hanging out with everybody.'…South Bay has a big family feeling.…It's a real positive environment,'" according to Munoz.

Comedians frequently cross-pollinated to other cities, carpooling to gigs as far as Sacramento, Modesto, Humboldt County. Comics from those areas would visit the San Francisco Bay Area to network and perform. Those who couldn't travel far and wide made the most of the area they had access to.

Munoz recalled, "I started running my own room. And that's how you get better.…When I first started, Big Al [Gonzalez] told me, 'The best hosts make great headliners.'"

In lieu of dedicated venues to accommodate the growing number of artists, comedians evolved into entrepreneurs. Showrunners and stand-ups produced one-nighters at music venues and monthly showcases at bars, often with irregular residencies. Self-produced shows became a vaunted endeavor, a necessary way to increase stage time and a valuable commodity to share with other enterprising peers.

Any given week in San Francisco could be overwhelming for even the most dedicated comedy fans. Alternative venues, like the subterranean space under video rental store Lost Weekend Video, or the pirate café Mutiny

Kaseem Bentley performs at Brainwash Cafe. *Courtesy of Anthony Medina.*

Pete Munoz. *Courtesy of Andrew Moore.*

Ben Feldman laughs and performs at Castagnola's. *Photo by and courtesy of Shawn Robbins.*

Radio, or the black box Dark Room Theater, could put on shows almost daily. And that's just a few places in the Mission District! Weekdays and weekends were littered with engagements at various frequencies. Monthly or quarterly events helped cultivate an audience without burning out the hosts, producers and audiences alike. Competitions and holiday extravaganzas were annual traditions. Comedy Day was the "company picnic." Comedians religiously hung out in the back of the Punch Line for the Sunday Showcase.

As much as San Francisco Bay Area comedy fans appreciated authentic, hilarious voices, the totality of the region's talent, and their competing marketing prowess, made it important for stand-up shows to stand out. A show's hook or a gimmick, a clever name or catchy concept, was just as important as how funny the performers were or the quality of the show production. And there were a lot of shows.

Club Chuckles. The Romane Event. Outsourced Comedy. The Business. The Setup. Comedy, Darling. Get Yucked Up. 5 Funny Females. Talkies. Good Times in the Grotto. HellaFunny. Hella Gay Comedy. Local Folks. Troubled. Ladies Love the Layover. Hysteria. The Dirty Show. Man Haters. Misery Index. Marga's Funny Mondays, Harvey's Funny Tuesdays. The Cynic Cave. Comedy Sharks. Kelly Annken's Lack of Variety Hour. Hired Killers. Pitch!. The Tabernacle. I'll Leave You With This. F Bomb Comedy. Our Little Theater. Critical Hit. Comedy Bodega. High Brow. Bad Asians. The Fungeon. Laugh City. Barrel Proof Comedy. The Blue Room. Smart Culture Show. Real Live Comedians. Stood Up. Things We Made. Comedians with Disability Act. Mark Pitta & Friends. For The People Comedy. Suganasty. Ebony and Irony. Comedy Machine. QComedy Showcase. Big Al's Big Ass Comedy Show. Haters Gonna Hate. The Friend Zone. BeFunny365. Laughter Against the Machine. Storking Comedy. Mermaid Show. Hand to Mouth. Starline Comedy. The People Under the Stairs. Blue Lagoonies. Mission Position. It's Only Two Minutes. I Think I'd Be Good at That. The Avengers of Comedy. The Dinosaurs of Comedy. The Vice Principals of Comedy. Joke-eoke. Moonlighting. Learn From Me. Millennials Ruin Everything. Nightlife on Mars. Comedy Oakland. Comedy Baseball. Charm Offensive. Funny Girlz. More Fun at Blondies. Cheaper Than Therapy. Live at Deluxe. Snob Theater. The Art Critique Comedy Show. Iron Comic. Far Easter. Kung Pao Kosher Comedy. Laughing Liberally. Verdi Wild Things. And so many more (including those with names too scandalous for this particular publication).

Twisted Biscuit started as three comics trying to make one another laugh at the edge of the world. The Sea Biscuit Cafe, at 3815 Noriega Street in San Francisco, was a few blocks away from the Pacific Ocean. The clientele was mostly surfers and blue-collar workers who wanted a beer in a part of town with low foot traffic.

Sal Calanni had taken over the reins of the open mic there from Tom Smith, who had taken over for Tony Sparks. The distance from the city's hub, the difficulty getting an audience there, was directly proportional to the difficulty getting other comedians to perform there.

"It sucked, it sucked. [The audience] hated us. And we never really had a crowd…" Calanni lamented in hindsight.

One night, when no other comedians showed up, Calanni, Robert Selander and "a thirteen-year-old kid named Boris," decided to swap each other's jokes and ape each other's styles.

Comedians are notoriously not the ideal audience for comedy. Not only have other comedians usually heard each other's jokes before, thus eliminating any surprise, most know every inflection and intonation. A peer's mannerisms, personas and delivery seep into the collective unconsciousness day after day, week after week, year after year. Ironically, most open mics are almost exclusively attended by comedians.

Trading each other's acts proved to be a lot of fun at the Sea Biscuit. And in the quintessentially SF comedy fashion, Calanni made it a competition. Twisted Biscuit launched in 2002. Prelims happened one week and the finals the following week. The task was simple: perform stand-up as another comedian. The performances often expressed scathing, hyper-specific roasts and mockery. Anyone outside of the scene, outside of that era, might find the experience nearly indecipherable. But the creativity the event inspired, the excitement and the champions crowned, were undeniable.

First Twisted Biscuit winner Miguel Fierro is credited with innovating multiple impressions in a single set. Will Franken won the second year with a set that appealed to "bitter open mic comics" about working in the local club system. Matt Morales won the third edition with a full storyline featuring ten impersonations. Max Curry, the fifth winner, was also renowned for his impressions. Mary Van Note won the fourth Twisted Biscuit in her first year in comedy.

"I think some people were definitely upset that I won. You know, here's this new girl and I beat out all the old timers. I think there were some hurt feelings there. But I think [Twisted Biscuit] helped cement my place with the community…[and] people took me seriously," remarked Van Note.

Twisted Biscuit proved to be extremely, yet specifically, popular. Sea Biscuit was more packed during the competition than any of the other fifty weeks in the year. Comics changed costumes in the venue's tiny bathroom. The show inspired some to produce and submit short films for the event.

"It all became us roasting each other. It was for [comedians]. There was no money. There was no prize. It didn't matter. It was just for fun. And it showed how creative comedians could be.…[Will Franken], I remember [said], 'Yeah, [the first week] I didn't think much of it, but it was so fun that I worked my ass off for that second week,'" Calanni reminisced.

Mo Mandel. *Photo by and courtesy of Shawn Robbins.*

Independent shows weren't just an opportunity to perform and network. They could be a gateway to touring, something to submit to a comedy festival, a workshop for bigger things. Shows became podcasts. Podcasts became shows. Big nights were sometimes pilot presentations, industry nights, DIY recordings or captured for documentaries. As hosts and producers migrated to and from San Francisco, concepts, brands and franchises followed.

The Bay Area comedy scene was reflective of emergent, worldwide comedy trends and a shifting paradigm. The internet opened up a wealth of possibilities, to produce and promote an ever-growing community of "comedy nerds." Social media was a boon for comedy folks to develop jokes, announce shows, communicate with their fans and with each other. Additionally, San Francisco, synonymous with Silicon Valley technocracy, launched regional online resources. QComedy.com promoted the city's queer comedy scene beginning in 1999. Launched in 2006, SFStandup.com listed open mic nights and the area's major shows while comedians bickered in the forums. Rooftop Comedy endeavored to capture and broadcast the nation's latest comedy wave on video and on comedy albums. Internet audio giant Pandora Radio, headquartered in Oakland, expanded to comedy recordings in 2011 with the introduction of its "Comedy Genome Project."

Comedian Mary Van Note started uploading videos to YouTube in 2006. It initially started as another way to express herself, to be creative. She was already doing stand-up and making zines. Her performances and early persona were unique, audaciously absurd and unflinchingly risqué. Van Note's videos were mostly stylized vlogs featuring dramatizations of her writing.

Mary Van Note performs at Dark Room Theater. *Photo by and courtesy of Shawn Robbins.*

A call for contributors from Nerve.com, a website dedicated to sexual topics, relationships and culture, felt like a good fit. YouTube featured one of her videos on its homepage. Her notoriety and point of view attracted the attention of the Independent Film Channel. When asked what she would like to produce as a web series, Van Note recalled, "I think I just mentioned, 'well, I have a crush on the mayor.'"

IFC commissioned *The Mary Van Note Show*, alternately known as *Gavin Really Wants Me*, a fictionalized portrayal of Mary Van Note as an "obsessed, nerdy, kind of weird girl" lusting after then mayor Gavin Newsom. The series featured numerous San Francisco comedians behind and in front of the camera. A film crew was cobbled together from Van Note's previous collaborations. Ten episodes were filmed, produced, broadcasted on IFC and hosted exclusively on IFC.com.

Van Note produced a live show with comedians involved in the project to celebrate. And she advertised with her unconventional style:

"I put up signs [that were a] handwritten letter to Gavin [Newsom] that I photocopied and plastered all over the city, inviting him to the show," recounted Van Note. Newsom was eventually alerted to this invitation, but he declined. He didn't want to ruin the joke. "I was like, 'Oh my gosh! He gets it!' That made me love him more."

A FEW FAMILIAR FACES

The Purple Onion was originally going to have puppet shows. Italian puppet shows. Owner Mario Ascione had renovated the dormant space underneath

his Cafe Macaroni restaurant. Dan Dion approached Ascione to see what he'd do with it. Dion, a lifelong comedy fan from Sonoma, had gone from an adolescent comedy vinyl collector to, as a teenager, loitering outside of the Punch Line asking adults to help him gain entry, to being the director of comedy programming at UC Santa Clara, to working the door at the Holy City Zoo right out of college, to producing comedy shows and photographing renown comedian portraits. He was involved in a majority of San Francisco comedy history from "The Boom" forward. But he always felt a longing for an earlier age, the 1960s San Francisco music scene. His shared interests made the Purple Onion, with equal amounts of comedy and music history, a permanent place of intrigue. And again, puppets.

Dion convinced Ascione to put on comedy shows in the historic space. Along with comedian Jim Short, under the banner "Jim Short and Friends," the Purple Onion returned to prominence in 2004. The "and Friends" was key. Anyone could show up. Dan and Jim's rolodex of local heavy hitters, comedy heroes and national headliners set to perform that week at one of the area's larger clubs, could work out and play among one of San Francisco's greatest rooms. The small, intimate, low-ceiling, wide and focused space, down a flight of very ADA-noncompliant stairs, filled with people excited to share in the spirit of the room. To capture the style and appeal of yesteryear, a dress code was enforced. Mort Sahl made a return engagement to North Beach comedy at the Purple Onion.

Eventually, the show was given to David Owens, a co-founder of SF Sketchfest. Some of the Purple Onion's greatest shows happened under Owens. Zach Galifianakis captured the venue's historic reemergence in his 2006 special *Live at the Purple Onion*.

In 2012, the building that housed the Purple Onion was sold. Dan Dion organized the last show. It was a marathon of the area's best comedians, a wake. Don Novello, as Father Guido Sarducci, performed the last rites.

The last show was a bittersweet affair. Ascione had kept the Purple Onion filled with multiple nights of comedy off and on throughout the years. Many show producers, seeking residual prestige or name recognition, or a chance to get in with the club, put on stand-up showcases on off nights to varying degrees of success. None could touch Jabari Davis.

Jabari Davis and Associates was a rarity in many respects. Davis was one of a few Black comedy show producers in San Francisco comedy history. For years, he presented multiple sold-out shows, multiple days in a week, every month. The production felt accessible but never cheap: a DJ spinning walk-up music, photographers and videographers. The show

Father Guido Sarducci helps say goodbye to the Purple Onion. *Photo by and courtesy of Dan Dion.*

regularly featured newer comics, future standouts like Byron Bowers and Tony Baker, visiting from the nation's other comedy scenes. The titular "Associates," comedians like Karinda Dobbins and Bryant Hicks, were hand-picked by Davis for featured sets. Tony Sparks would warm up the crowd and guide the evening. Davis, a charismatic comedian who joked about organic produce and his tough neighborhood, often performed on the bill as well. And everyone got paid.

Comedy would once again have a home on Columbus Avenue between Jackson Street and Kearny Street. Doc Rickett's served chic food and drinks up top. Doc's Lab offered live comedy and music down below. Restaurateur Christopher Burnett opened the two venues in 2014; Jeff Zamaria served as the venue's comedy talent buyer. Zamaria started his career as a doorman at Cobb's Comedy Club before promotions to manager at Cobb's and San Francisco Punch Line as well.

Everyone involved with Doc's Lab wanted an elevated experience to honor the history and spirit of the room. The Purple Onion space was fully renovated; everything from the bathrooms, to the sound board, to the stage layout was reconsidered and adjusted. "It was very nice. Sometimes I even thought it was kind of 'too nice,'" reflected Zamaria.

While at Doc's Lab, Zamaria was careful not to run afoul of Live Nation, the area's major comedy buyer. A national headliner's contract often included exclusivity in the region for a certain timeframe. Many high-profile comedians declined bookings at Doc's Lab to avoid damaging any relationships. Those specific restrictions, and other budget concerns, dampened Doc's Lab's ability to grow, according to Zamaria. Both the restaurant and entertainment space closed abruptly in 2018.

Karinda Dobbins.
Photo by and courtesy of
Shawn Robbins.

Across San Francisco, in the Richmond District, another institution opened its doors to comedy. Dirty Trix Saloon was like many establishments on Clement or Geary: a long wooden bar, high ceiling, pool table, jukebox and sports flashing on mounted televisions. But according to the owner, Robin Williams and Dana Carvey used to perform there. The bar used to be known as the Holy City Zoo. This piqued the interest of Andrew Moore and Justin Gomes. Moore and Gomes were childhood friends from the East Bay who both moved to San Francisco for college and worked at a golf course near Dirty Trix. They were also actors, improvisers and stand-up comics who started the comedy troupe Sylvan Productions when they were teenagers.

Dirty Trix and the golf course had a "shift drink" exchange, where members of each staff could drink for free at the other's establishment. It was also kismet for Moore and Gomes to live nearby. Still, it took a year for the owners to allow them to put on a comedy show. And there were speed bumps: hanging posters on Clement Street required a special permit paid by the Dirty Trix owners, to their chagrin. Chairs needed to be sourced, repaired and stored on the premises. Opening night was an open mic launched Wednesday, April 20, 2011. The original idea was for Moore, Gomes and other Sylvan Production members Andrew Holmgren and David Gborie to rotate as the evening's hosts. Relaying the show each week to another troupe member, sometimes mid-show, made the Dirty Trix open mic's long and loose nights more manageable. In the end, it was primarily Moore at the helm.

Dirty Trix expanded comedy nights to Tuesday and Saturday nights, creating more opportunities for new shows, new hosts and new comedy in

Mike Drucker performs at Dirty Trix. *Courtesy of Andrew Moore.*

David Gborie on stage at Dirty Trix, home base for Sylvan Productions. *Courtesy of Andrew Moore.*

RETURN OF THE KINGS

Comedy in San Francisco proved to be as eternal as some of its earliest luminaries.

Paul Mooney, Oakland native, a writer for Richard Pryor, mentor and one of the most important stand-ups in modern history, made multiple co-headliner engagements with fellow modern comedy legend Dick Gregory. The duo converged to perform a run at the Black Repertory Theater in Berkeley in 2012, at the Palace of Fine Arts Theatre in 2014 and at Tommy T's in Pleasanton in 2015. Mooney was a wildly acerbic and relentless social commentator. Gregory was less jokey and more conversational, political, notably taking time to speak about food advocacy.

Across the water and over a bridge, Mort Sahl similarly returned to the stage at the Throckmorton Theater in Mill Valley. His residency at Throckmorton was an intimate affair, located in a parlor with a sixty-to-eighty-person capacity adorned with classical murals. Sahl, with his trademark newspaper and cardigan, joked about the news of the day. Audiences were "old school": loose, present, not too self-serious or self-important. Saul was an equal opportunity jokester, making fun across the political spectrum. The occasional conspiracy theory could be excused or entertained from a legend like Mort Saul; he had seen and survived it all.

"It just felt like everyone was hanging on every word. Because they knew they were legends....No matter if [they] just recited the alphabet, we just stood there and took it. We just loved it.... In terms of seeing legends, I feel that you could always see all the [comedians] the rest of the country admires any time here in the Bay Area," comedian Ethan Orloff reflected about watching those Mooney, Gregory and Sahl shows.

Comedians often get better with age, with experience, with time and perspective. And, if you can find a proper place to showcase them, like in San Francisco, it's a treat to watch a master at work.

the historic space. Some familiar faces stopped by as well. Robin Williams visited Wednesday's open mic, only to watch, to see the space filled with comedy again. And the next week he asked to go up.

"Robin's here! Robin's here!" People texted, tweeted, posted, ran down Clement Street to spread the news. The crowd of regulars, staff and comedians gathered tightly around the "stage"—two adjacent wooden boxes pressed together—to be around Robin Williams. "Have a moment without it!" Robin shouted at all the audience members hidden behind their phones, who were trying to capture the experience. Robin played with the false curtain on the back wall of the stage. The microphone fell out of its stand. The energy hummed, and the atmosphere swelled. Every line got a laugh. Robin noticed another person recording him in the wings. He pleaded that they stop filming him. "That's Sweet Gail," responded another audience member. "Who?" Robin inquired.

Sweet Gail was a notorious and enigmatic character in the San Francisco open mic scene. In addition to her curious misnomer stage name, she had a penchant for elaborate rants rather than set-up punchline jokes. If there was a sign-up list, and there would be an audience there, Sweet Gail would often find a way to get stage time. And if it was your first time encountering Sweet Gail, you'd quickly learn that she's not to be trifled with.

That night at Dirty Trix, Sweet Gail refused to stop filming Robin. She allegedly yelled something to the effect of, "Leave me alone! Tell your jokes!" Robin Williams vs. Sweet Gail: legend and urban legend, icon and iconoclast, irresistible force and immovable object. Nothing could embody the Dirty Trix spirit more than that.

While there will always be "good ghosts" in the bones of 408 Clement Street, Dirty Trix wouldn't last. Due to a dispute between management and the building owner, the bar's lease was not renewed. After nearly three years, just as Dirty Trix was gaining momentum, the open mic, the showcases, the new old home for comedy was closed in early 2014.

#SaveThePunchLine

Stand-up shows in the San Francisco Bay Area were often at the mercy of nonnegotiable ideals or disparate business interests. Some comedy nights were endeavored as a venue's "last gasp" to drum up awareness (and money) before they either closed, a lease ran out or a building was sold. Sometimes businesses reorganized or a manager/owner deemed comedy, or a particular

producer, not worth the trouble. Many popular shows and producers were forced into circumstantial rebirths, sojourning from venue to venue. No institutions were safe, not even San Francisco's oldest and longest-running comedy club.

News broke on May 7, 2019, on the website Broke Ass Stuart that the company Morgan Stanley Real Estate, owner of the building that housed the San Francisco Punch Line, was refusing to renew the comedy club's lease. The Punch was scheduled to be evicted that August. There was an immediate outpouring of emotion in the press and over social media.

> *I don't know where I would be without the Punch Line and I know I'm not alone in the comedy community—it is our spiritual home.*
> *—Margaret Cho*

Dave Chappelle and other comedians quickly booked shows for the location's last hurrah. The Punch Line's management assured everyone things would continue at another venue. A rally was organized on the steps of San Francisco City Hall by local comedians. "Headlined" by Chappelle, W. Kamau Bell, Nato Green and Supervisor Aaron Peskin, the community urged that the Punch Line remain at 444 Battery Street and be registered as a Legacy Business, which helps safeguard "longstanding, community-serving businesses."

A lease agreement between Morgan Stanley and tech giant Google for the twenty-five-story tower and annex that housed the comedy club complicated matters. Google agreed that the Punch Line should remain at the location, as it had for decades. "Google is absolutely open to participating in conversations with city officials and the community regarding the preservation of the Punch Line," said a statement. After subsequent negotiations, the Punch Line was able to sign a new multiyear lease and receive Legacy Business status in late July 2019. Comedy, as a culture, community and art form, successfully saved a historic home for laughter in San Francisco, just as a new threat loomed.

9

SANITIZED COMEDY

THE PANDEMIC YEAR(S)

Early in 2020, the world was made aware of COVID-19. As it spread throughout the United States, life as we knew it came to a stop. The status of the pandemic forced Americans to change how they lived, how they worked and how they were entertained. Movies, music concerts and Broadway shows were all canceled for the time being. Naturally, stand-up comedy followed suit.

The week before the California statewide shelter-in-place order, there were still comedy shows and open mics. The week of March 8, warnings about holding events surfaced. Many shows were canceled. At other shows, comedians brought cleaning products to wipe down mics and mic stands before doing their set. Emo Philips was scheduled to headline the weekend of March 13–14 at the Punch Line in Sacramento. The Punch Line and Cobb's Comedy Club in San Francisco, however, canceled all shows that weekend. Usually, Emo Philips would greet his fans at shows, but not this time. From the stage, he commented, "I'm so sorry that, because of the health risk, I won't be able to say hi to you after the show; I love meeting my fans. That said, I've noticed that whenever I do meet my fans, we both tend to walk away a bit disappointed." Philips graciously refrained from his meet and greet. Philips would be the last national headliner a major Bay Area comedy club would see for months to come. On Sunday, March 15, 2020, California began to phase in a quarantine by ordering all bars and restaurants to close by 9:00 p.m.

Lights n' Punchlines at the Milk Bar, produced by Drea Meyers. Comedy show on the sidewalk of Haight Street. *Photo by and courtesy of Drea Meyers.*

Once in quarantine, many Bay Area comedians faced a creative, existential and, for some, financial crisis. If a comedian tells a joke and no one is around to hear it, does anyone care, let alone laugh? What is stand-up comedy if there is no live audience? What qualifies as a live audience? Is the art and business of stand-up comedy possible from one's home? If and when things "open up" again, what will comedy look like? Will comedians perform in masks? Will shows only be allowed audiences with 20 percent of seats filled? Honestly, 20 percent capacity would be a good night compared to some of the dive bar comedy shows comedians have done! Would comedians have to rethink stand-up and what it means to be a comedian?

Zoom, a video communication platform, became a household name nearly overnight. Zoom became a popular technology to keep schools, workplaces, friends and families connected throughout the pandemic. Because of the popularity of the technology, it inevitably became useful for entertainment (and thus, comedy) across different user groups. One comedian in the Bay Area who started an online show early in the pandemic was CYNTHIAINPUBLIC. CYNTHIA started comedy in August 2019, just before the pandemic. She had a baseline of what open mics and showcases were like. Early in the quarantine, she facilitated online open mics, showcases and pop-up shows under the name Bangou Productions. CYNTHIA was joined by comedians across the Bay Area, the state, the country and eventually the world, opening the comedy communities' borders across state and international lines.

Since its inception, online technology has been an enabler of communication within comedy communities. During the pandemic, however, the international comedy community connected more and more, in part due to social media resources such as the Displaced Comedians Facebook group. The group, started by Niko Lukoff, facilitates a place for comedians and show producers to share online open mics and show opportunities. Lukoff, who was born in San Jose but currently lives in Nampa, Idaho, started comedy in August 2019. Like CYNTHIA, Niko had an interest in continuing his comedy progress online. At one of the first online open mics he attended, he observed, "I enjoyed it, while being strange and different but more similar to real life than different....It's still a bunch of people just trying to make each other laugh, doing their best with their environments to connect and land punches and tags." Lukoff had not been a comedian long before the pandemic hit, so he was able to continue to develop his comedy over the year when shows were outlawed. The Displaced Comedians Facebook page became a place where comics could connect and find online venues as well as audiences across the world.

Once Bay Area comedy went through enough stages of grief to turn denial and despair into acceptance, comics in the Bay Area started producing online showcases. Many tried to run shows that paralleled their live counterparts while others experimented with show formats and new projects for social media. Using Zoom, one could conduct a game show, a live podcast, an online competition, a show and tell, Pictionary, whatever you could think of, all with a live audience in the Zoom meeting itself or streaming online using Facebook Live or the Twitch streaming service. The new formats allowed comedians to be unscripted and improvisational, possibly funny

if they embraced the awkwardness of such a jarring change. Some shows like Impromptu, facilitated by Jeanette Marin, Clay Newman and originally Mac Ruiz, built on the tradition of San Francisco improvisation. Like Paula Poundstone's show at the Other Cafe, comedians are expected to refrain from their regular material and only respond to prompts. Far from the busy window of the venue on Carl and Cole, but the exercise of improvisation in comedy was still being utilized.

Audiences also enjoyed being part of an interaction and community they found with online comedy. It became both entertaining and social. Comedians could also make some much-needed money thanks to the low overhead of a monthly Zoom fee (if at all) and an appreciative audience who either paid ticket prices for a Zoom link or offered tip donations to the shows and comedians through online payment applications such as Venmo and PayPal.

Many longstanding Bay Area shows transitioned to the online format. The San Francisco Punch Line's Sunday Showcase went online, as did Comedy Oakland. The Mental Health Comedy Hour hosted by Wonder Dave and Kristee Ono had monthly shows, which included one with former San Francisco comedians Guy Branum and Margaret Cho.

Even in its twenty-eighth year, Kung Pao Kosher Comedy adapted. Kung Pao, the longest-running comedy show in San Francisco, produced by Lisa Geduldig, ventured online. Kung Pao is held yearly with the promise of "Jewish Comedy in a Chinese Restaurant on Christmas." In addition to presenting stand-up luminaries like Judy Gold, Marc Maron, Elayne Boosler and Gary Gulman, the show provided an intimate setting to see legends like David Brenner and Shelley Berman. The late, great Henny Youngman performed his last show ever at Kung Pao Kosher Comedy in 1997.

Geduldig observed, "[Henny Youngman] really put the show [more] on the map....I think it professionalized it more [by] having this big time headliner. And, on a personal level, his grandkids got to see him perform for the first time....The last time they saw [their] grandpa alive was onstage, dignified...wearing a tuxedo, [and] performing as opposed to in the hospital, dying of pneumonia. So, on a personal level, I liked that it had that effect with his family."

As it increased in popularity, Kung Pao Kosher Comedy offered two shows a night with upward of 2,200 to 3000 people in attendance across three or four days. In the show's early years, Geduldig sold many of the tickets from the Modern Times bookstore and out of her apartment; she recalls the names of regulars (and their party sizes) like she would her own family members.

Henny Youngman performing at Kung Pao Kosher Comedy with Lisa Geduldig. *Courtesy of Lisa Geduldig.*

Kung Pao Kosher Comedy cultivated several personal, tactile touches: a large banquet room at the New Asia restaurant and fortune cookies with Yiddish proverbs. Those elements needed to be adapted considering the pandemic. There also had to be a great comedy show.

The ten-person banquet-style tables became breakout rooms on Zoom. People could buy an entire table or "sit" with "friendly strangers." The fortune cookies, locally sourced from a San Francisco factory that Geduldig has used for years, were available for online orders. A video detailing Kung Pao Kosher's history opened the shows. Despite the unfortunate circumstances, Kung Pao Kosher Comedy was able to entertain up to two thousand people over three days, connect family members from all over the globe—and allow Geduldig to avoid the schlep to the restaurant and twelve-hour days—all with a push of a button.

Geduldig, building on the success of her yearly show, branded the new online show *Lockdown Comedy* in July 2021 with comedians like Judy Gold, Wendy Liebman, Greg Proops and Marga Gomez performing throughout the first year of the show.

Online innovations didn't come without scrutiny from the comedy community. Many questioned if comedy online qualified as true stand-up comedy. Eventually, comedians acquiesced to the new format, although with

Mean Dave performing at Comedy Day in September 2021. *Photo by Nina G.*

much reluctance. East Bay comedian Mean Dave added a new bit to his act thanks to the reaction of comedians to Zoom comedy:

> *A lot of my comedian friends say, "That isn't real comedy you're doing on Zoom, Dave." I've had phone sex and internet sex for decades and not once has anyone barged in my room saying, "That's not real sex you're having there, Dave." Well it would be if you joined in! So, I just call it Stand-up Comedy: The Video Game.*

DRIVE-IN SHOWS

The debate of what constituted stand-up comedy was shelved once comedians were able to venture back into live comedy. There were requirements for COVID protections in the early return to live shows. Shows would have to be outside, socially distanced, and depending on the layout of the stage and audience, comedians would need to mask up. Some of the first shows to occur were drive-in style. In the Bay Area, a couple of them were located in Santa Cruz and Newark (yes, there is a Newark in California too).

Comedians Sam Weber and Brian Snyder produced a drive-in show at a couple different parking lots in Santa Cruz. *Comedy Audiences in Cars Watching Comedy*, as the show was titled, is just a simple stage made from a coffee table and a mic setup with a radio transmitter so people stay in their cars to listen to the radio frequency and (hopefully) see the comic on the coffee table stage. The show was well received early on and became a fun challenge throughout the pandemic, as no honking was allowed, only cars flashing lights and whatever laughter you might be able to hear in the void of the parking lot. On the other end of the Bay Area Comedy drive-in spectrum, the Newark Comedy Drive-in was the brainchild of the city's councilperson/vice mayor and one-year comedy novice, Mike Bucci.

Bucci's show was especially unique because of the set-up. The show happened in an overflow parking lot of a historic events hall with a bar and restaurant called Swiss Park located in Newark. The parking lot stood between a modest hotel and an apartment building. Bucci built a two-story stage that looked like a miniature wrestling ring, with the ropes included. To get to the stage, a comedian had to climb a ten-foot ladder while stage hands changed the microphones between comedians. Once on stage, the comedians performed to a full lot of parked cars. Their image was projected

Comedian and host Mean Dave with Mike Bucci, producer of the Newark Comedy Drive-In. *Nina G's collection.*

onto a big blow-up movie screen that was thirty-two feet wide. Cars had to tune in to a frequency on their radios or phones to hear the comedians. Comedians knew they were doing well if they saw the cars flashing their lights. They knew they were killing if the parking lot exploded with cars honking their horns. Tragically for the comedians, honking had to stop if the police showed up due to complaints, which didn't happen until the last few shows.

The Newark Comedy Drive-in was a success and had local headliners like Larry "Bubbles" Brown perform. Shows would have a combination of fresh eyes and ears mixed with return customers from previous shows. The show even collected a good amount of money to support the comedians considering the shows were free to attend and a number of volunteers staffed the parking lot crew as well as the set-up/take-down crew. For many Bay Area comedians, it was the first live show they had done since the COVID quarantine, and they relished in the flashing lights and car honking, knowing they may not get a chance to do this again for awhile. The Newark Comedy Drive-in ran from June to September 2020. Who knows if we will ever see it again? Much like the online shows, there are some new innovations that might stick around even after the pandemic. Perhaps drive-in comedy will be one of those.

OUTDOOR SHOWS

Before bars and restaurants had outdoor dining, some comedians held open mics in local parks. Bringing a mic and an amplifier, they attempted unsanctioned shows. Inevitably, bars and restaurants were allowed to open for outdoor dining and drinking. Comedy shows weren't far behind, as comedians were eager to get back on stage. Shows popped up all over the Bay Area in San Francisco curbside parking spaces and parklets as well as Walnut Creek parking lots. Outdoor shows spread like a fire in California, all across the Bay, at different points throughout the pandemic, thanks to comedians and producers who showed it was possible early on, such as Pam Benjamin (multiple sites in San Francisco), Casey Williams (Sally Tomatoes/3 Disciples Brewing in the Santa Rosa area), Drea Meyers (multiple sites in San Francisco), the #HellaFunny crew (Copper Spoon in Oakland, Neck of the Woods in San Francisco), Pat McCoy (multiple sites in Contra Costa area), Kabir Singh (Players Pub & Pianos in Danville, Spin a Yarn Steakhouse in Fremont), Pete Munoz (Vito's Famous Pizza in San Jose) and many more in tow.

The Set-up at Gasser Garden, an outside venue in a lot between buildings on Second Street. *Photo by and courtesy of Abhay Nadkarni.*

Far from the intimacy of clubs like the Purple Onion, the new outdoor environment offered its own challenges, but enthusiastic audiences helped bridge the gap. It was like comedians and their audiences were finally in the same boat, just being happy to be out of the house and enjoying a group experience.

COMING OUT OF THE ASHES

On Friday, April 2, 2021, Jerry Seinfeld performed live in a nightclub for the first time at New York City's Gotham Comedy Club. COVID-19 hit New York especially hard, so the reopening of the club at partial capacity of 100 seats felt especially hopeful. By April, with the vaccination rollout and numbers of the sick and dying going down, the San Francisco Bay Area started to reopen. The second week of March 2021, local counties were advised that they could begin to reopen inside operations at reduced capacity. Tommy T's was the first comedy club to reopen indoors. Barbi

ALAMEDA COMEDY CLUB

During the pandemic in the East Bay, a new club opened—The Alameda Comedy Club. Patrick Ford opened it with his wife and brother-in-law. Ford briefly dated his now wife when they were in their twenties and became reacquainted later in life. Their first date, the second time around, was at Cobb's Comedy Club at the Cannery location. Ford wanted to start a club that harkened back to the intimate club experiences of the early comedy boom. Alameda was a strategic place to open a club because of its central location. Additionally, there is not a full-time comedy club between San Francisco and Pleasanton.

In October 2019, Ford signed a lease with a plan to open the club in May 2020. Construction began but came to a screeching halt in March 2020 because of the pandemic. For two months, progress was idle because of the shelter-in-place orders. The unique thing about the Alameda Comedy Club property is the large patio that was originally planned to be a hangout space between shows. This back patio area was quickly converted into a space that could sustain

Patrick Ford, owner of the Alameda Comedy Club, with comedians Dan Smith (*sitting next to his wife*) and Jade Theriault. Both were part of the Comedians with Disabilities Showcase that the club hosted (with their wheelchair-accessible stage) on May 20, 2021. *Nina G's collection.*

outdoor comedy shows. Ford consulted with an architect on an outdoor club setting that was compliant with COVID guidelines as well as accessible under the Americans with Disabilities Act. The result was thirteen tables with a forty-patron capacity. In October 2020, the Alameda Comedy Club opened for a weekly schedule of shows, which included national headliners, showcases and open mics. For each show, Ford ensured the comedians' safety by using wireless mics that are UV sanitized between comics. Comedians are announced from off-stage to minimize contact.

In December 2020, COVID numbers forced another quarantine order, and the Alameda Comedy Club went into hibernation with hopes of opening in the coming months with outside or reduced capacity audiences in their showcase. Ford believes that COVID and the quarantine will do little to change comedy in the long run. He cites the terrorist attacks on 9/11. Many thought after 9/11, America would be unable to laugh, but in the end, we discovered how important a release laughter can be. Comedy is resilient, and Ford hopes the business of comedy will be as resilient as well. He added, "The job of being a comedian doesn't change fundamentally. One voice. One microphone. One spotlight. The audience laughs or they don't. That's the job...it's a pure art form."

Evers, a bartender at Tommy T's for twenty-five years, reported that Mike Epps performed opening weekend and sold out six shows, adding a seventh at $240–$280 a table (four seats). Reduced capacity meant that the regular room, which normally seats approximately 400, sat about 125 to 150 people per show.

The Alameda Comedy Club joined Tommy T's as they slowly got back to their main showroom with a lineup that included nationally touring headliners like Eddie Pepitone and Cathy Ladman. By April 2021, open mics, showcases and shows with major headliners were being produced nearly every night of the week in the Bay Area. Cobb's Comedy Club opened for indoor shows in mid-May, and the Sacramento Punch Line soon followed. Eventually, the San Jose Improv reopened on June 24, 2021, followed by San Francisco Punch Line in July, after all restrictions had been removed, although some restrictions returned in later months to combat the

spread of the Delta variant. As of September 2021, Rooster T. Feathers had not announced a reopening.

The performance of stand-up comedy is resiliency in action. A comedian bombs one night but quickly gets back on stage chasing the next laugh. A joke doesn't work? The comedian rewrites, re-delivers and restructures the joke until it does. The art of comedy is an exercise in resilience, which you oftentimes see in the charter of comedians who truly love the art form. This adaptability emerged in the pandemic as a form of "comedy Darwinism," a term coined by local comedy producer Dena Ware. Those who loved comedy enough to adapt and continue their development in new, strange, unchartered environments flourished.

In Conclusion...

A major aspect of any comedy community is the community itself. There are often beefs, rumors and jealousies in nearly all comedy communities, but there is also friendship, support and pride. The San Francisco comedy community is just big enough to multiply into the many subcommunities within, but also small enough that many people can move easily from one community to another, especially if they are funny or host an attractive show other people want to get on. Since San Francisco is removed from the more popular hubs of the entertainment industry, more freedom exists for the performers to try different things. This common bond of creative freedom fosters relationships that not only support each other as performers and mentors but also real friendships with each other as human beings.

Frank Kidder, Jose Simón and Tom Ammiano were some of the early mentors of San Francisco comedy. This tradition continues with comedian mentors like Tony Sparks, DNA of Santa Cruz, Pam Benjamin of Mutiny Radio and many others who gave consistent space and support to budding comedians. In addition, there are countless formal and casual relationships comedians have with open mic hosts, comedy coaches, writing groups and friendships that propel one another to the next step in their comedy development, even if that step is transitioning out of comedy. These relationships are important to the community, and sometimes these friendships can keep comedians afloat when going through difficult times. Carrie Snow shared, "That was the thing with comics. You got to be who you were...[different qualities that people are often judged on] doesn't matter. Nobody cared who you were as long as you were funny. The people you first

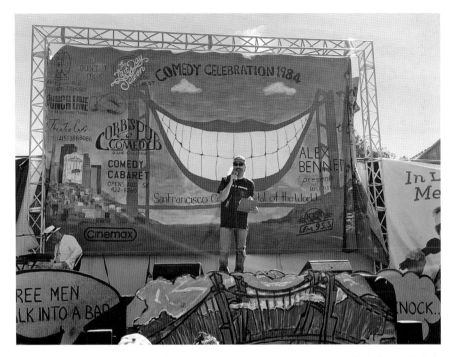

DNA has mentored many comedians and supported the growth of comedy in Santa Cruz for years. For twelve years and counting, he has led volunteer efforts at San Francisco's Comedy Day. *Courtesy of DNA.*

met when you first start are so important to you." Bay comedy is broad and diverse enough that comedians can find their own niche and flow freely to other subcommunities that welcome their comedy.

For many, the heart of San Francisco comedy was Robin Williams. The friendship and altruism toward the comedy community and beyond was seen in so many ways. One example of this was recollected by Larry "Bubbles" Brown one night at the Holy City Zoo in late summer of 1987.

Producers Rollins and Joffe were checking him out for a possible HBO appearance. They requested to see him one more time after seeing him kill in Los Angeles and arranged to do so at the Holy City Zoo. Joffe and Rollins invited their famous client Robin Williams to accompany them to both shows. Larry had a good set, but another comic destroyed the room and ended up getting the spot on the special, signing the contract on the bar of the Zoo. That is when Larry disappeared into the San Francisco fog to make his way home. It was around 11:00 p.m. Knowing what the possible TV appearance might have meant to Larry, Robin was concerned about

him and started asking others where he went. Around 2:00 a.m., Larry got a call. It was Robin calling to comfort him. "I don't remember what we talked about. He said you had a good set. It [getting the TV spot] is out of your control. Don't worry about it blah, blah, blah. Then he said, 'I'll see you around campus [meaning the comedy clubs].'" This meant a lot to Larry, especially in the age before the internet, where it took extra effort to find his unlisted phone number. Robin was well into his fame as a movie actor by then yet still reached out to a fellow comedian out of concern, which was characteristic of many interactions Bay Area comedians had with Williams. Like many in the Bay, Larry misses his friend and colleague.

San Francisco Bay comedy is known for its many improvisational styles of comedy. Comedians have more stage time in a vast array of settings to search for, discover and develop their comedic voice. The exploration Bay Area comedians can engage in, free of industry insiders, is something that has fostered talent for decades; it still does. Robin Williams helped establish this tradition in Bay Comedy. Another tradition, one that Robin Williams personified, was giving back to the community, whether it was *Comic Relief* supporting unhoused causes, granting career opportunities for other comedians or supporting events like Comedy Day. Hopefully, San Francisco Bay Area comedians continue to embrace and carry on a heartfelt, profound and generous tradition that makes the Bay Area one of the best places in the world to be a stand-up comedian. #BeRobin

BIBLIOGRAPHY

"About." *Bay Area Black Competition*, 2012, Internet Archive, https://web.archive.org/web/20120516123933/http://www.blackcomedycompetition.com/about.html, Accessed 26 August 2021.

Ahlgren, Calvin. "Talented Comics Are Making San Francisco a Laughingstock." *San Francisco Examiner*, May 20, 1979.

Alexander, Dick. "The Purple Onion—The Birth Place of Stars—Is 25." *San Francisco Examiner*, January 17, 1978.

Ammiano, Tom. *Kiss My Gay Ass*. San Francisco: Bay Guardian Books, 2020.

Andrews, A. "Spotlight: Bobby Bitter, Vegas Lizard." *Harpoon Magazine*, December 1990.

Armstrong, David. "Other Cafe Show Relives Comedy's Roaring '80s." *San Francisco Chronicle*, September 19, 2010.

Bagwell, B. *Oakland: The Story of a City*. Oakland, CA: Oakland Heritage Alliance, 2012.

Barr, R. "Roseanne Barr and Phyllis Diller Never Seen Before Interview Part 1." YouTube, https://youtu.be/VWJeI_8R46Y.

Berkeley News. "Words of Freedom: Video Made from Mario Savio's 1964 'Machine Speech.'" September 30, 2014. https://news.berkeley.edu/2014/09/30/words-of-freedom-video-made-from-mario-savios-1964-machine-speech/.

Berlin, Leslie. "The Inside Story of *Pong* and the Early Days of Atari." *Wired*. November 15, 2017. https://www.wired.com/story/inside-story-of-pong-excerpt/.

Broadway World. "'Joan Rivers Theatre Project Premieres' at Geffen Playhouse." November 9, 2007. Accessed August 18, 2021. https://www.broadwayworld.com/los-angeles/article/Joan-Rivers-Theatre-Project-Premieres-at-Geffen-Playhouse-20071109

Brown, Cecil. *Pryor Lives!: How Richard Pryor Became Richard Pryor*. N.p.: Createspace, 2013.

Bruce, L. *Lenny Bruce: Let the Buyer Beware*. Shout! Factory, 2004.

———. *The Sick Humor of Lenny Bruce*. Fantasy Records, 1959.

Calanni, Sal. ep.147 w/ Jasper Redd (Epiphany, SF, Tecmo Bowl). *Who the Eff Is Sal Calanni?* (podcast). Accessed August 18, 2021. https://www.salcalanni.com/podcast.html.

California Community College. "Robin Williams." Accessed August 13, 2021. https://www.cccco.edu/About-Us/Notable-Alumni/Robin-Williams.

Calvin A. "Talented Comics Are Making SF a Laughingstock." *San Francisco Examiner*, May 20, 1979.

Campos, R., and D. LoCicero. *Three Still Standing*. Beanfield Productions/ZAP Zoetrope Aubry Productions, 2014.

Canle, J. "Trend: Gay Stand-Up Comedians." *Entertainment*, December 10, 1993.

Casper, W. *Whoopi Goldberg: Comedian and Movie Star*. Springfield, NJ: Enslow Publishers, 1999.

Clifford, Terry. "A Most Unpriestly Priest Named Guido Sarducci." *Chicago Tribune*, August 17, 1980.

Cohen, R. "Lenny Bruce Is Alive and Well and Opening at the Brentwood." *St. Louis Jewish Light*, January 8, 1975.

Cohen, Thomas A. *hungry i Reunion*. Pacific Arts, 1981.

Coleman, Janet. "Making Whoopi." *Vanity Fair*, July 1984.

Czajkowski, Elise. "Talking to W. Kamau Bell About 'Totally Biased,' Calls from Chris Rock, and Becoming a Part of the Political Conversation." *Splitsider (Vulture)*. August 16, 2012.

Diller, Phyllis. *Like a Lampshade in a Whorehouse: My Life in Comedy*. New York: TarcherPerigee, 2016.

East Bay Express. "Best Comedy Night: Jokes That Won't Insult Your Intelligence." May 2, 2007.

Eichelbaum, Stanley. "A Clearinghouse for Comedians." *San Francisco Examiner*, July 17, 1977

Federman, Wayne. "Holy City Zoo." *The History of Stand-Up*. Season 2, episode 1, Podglomerate, June 4, 2019. https://www.thehistoryofstandup.com/episodes/s2-ep-01-holy-city-zoo.

Femprov. "Femprov Gals." Accessed August 13, 2021. https://femprov.blogspot.com/p/gals.html.

Fox, Jesse David. "Margaret Cho Is Proud of All Her Children." *Vulture*, March 25, 2021.

Fox, Michael. "Castro Cabaret Thrives On Catering to Locals." *San Francisco Chronicle*, October 11, 1992.

Frank, Aaron. "Comedian Kasher's Memoir Kasher in the Rye: 'I Was Violent. I Was Sexist. I Was a Pig." *LA Weekly*, April 13, 2012.

Giovanni, Jim. *Dangerous Laughs*. N.p.: independently published, 2019.

Graham, Bill, and Robert Greenfield. *Bill Graham Presents: My Life Inside Rock and Out*. Cambridge, MA: Da Capo Press. 1992.

Grammy Awards. "Artist: Bob Newhart." https://www.grammy.com/grammys/artists/bob-newhart/15054.

Hamlin, Jesse. "Life Met Art Here/Part One: 1965–75." *San Francisco Chronicle*, June 13, 2005.

Hooper, Joseph. "Comics Looking for the Last Laugh." *Palo Alto Weekly*. Date unknown. From archive of Larry Brown.

Huang, Fan. "Alumnus Talks Professionally Clowning Around in Stand-Up Comedy." *Daily Californian*. February 18, 2014.

Jerry's Brokendown Palaces. "Boarding House, 960 Bush Street." Accessed February 15, 2012, http://jerrygarciasbrokendownpalaces.blogspot.com/2011/09/boarding-house-960-bush-st-san.html.

Johnston, L. "Chronicle Comedy Day: 60,000 Tickled by Dozens of Jokers." *San Francisco Chronicle*, July 31, 1989.

Jose Theatre. "The Jose." Accessed August 17, 2021. https://www.sanjose.com/underbelly/unbelly/doom/jose.html.

Kakutani, Michiko. "Chaplin's Artistry Given Short Shift." *Sacramento Bee*, May 7, 1989.

Kaliss, Jeff. "Cobb's Owner a Stand-Up Guy/Sawyer Adds Touch of Politics." *San Francisco Chronicle*, May 27, 2005.

Karvoski, Ed. *A Funny Time to Be Gay*. New York: Gallery Books, 1997.

Katz, Barry. "Marcus King." *Industry Standard w/ Barry Katz*. Episode 243, 2018.

Langan, Maureen. "Actor and Director Debi Durst" *Hangin' with Langan*. Season 2, episode 18. Accessed May 30, 2021. https://player.fm/series/hangin-with-langan/actor-and-director-debi-durst-s2-ep18.

Las Vegas Review-Journal. "Brotherly Laughs." November 2, 2008. https://www.reviewjournal.com/life/brotherly-laughs/.

Library of Congress. "From Country Classic to Comedy First: Additions to National Recording Registry Announced." https://www.loc.gov/loc/lcib/1105/recordings.html.

Lipsky, William. *Gay and Lesbian San Francisco*. Charleston, SC: Arcadia Publishing, 2006.

Mackay, Kathy. "Rebirth of SF Comedy at the Zoo." *Los Angeles Times*, January 22, 1978.

Mak, Alex. "The Legendary Punch Line Comedy Club Is Closing." *Broke Ass Stuart*, May 7, 2019. Accessed August 18, 2021. brokeassstuart. com/2019/05/07/the-legendary-punch-line-comedy-club-is-closing/.

Mandel, Bill. "Not Just For Laughs." *San Francisco Examiner*, August 4, 1991.

Marino, Joe, and Jesse O'Neil. "Jerry Seinfeld 'Felt So at Home' Reopening Gotham Comedy Club." *New York Post*, April 2, 2021.

Martin, Steve. *Born Standing Up*. New York: Scribner, 2008.

Miles, O. "For Comics and Jokes: The Comedy Scene Is Proving Ground." *Berkeley Gazette*, April 1, 1975.

Nachman, Gerald. *Seriously Funny: The Rebel Comedians of the 1950s and 1960s*. N.p.: Pantheon, 2009.

Napa Valley Register. "Comedy Shops Proving Huge Success in San Francisco." March 21, 1979.

National Public Radio. "1950s 'Porgy and Bess' Castmember Maya Angelou Reflects on Production's Significance." *Tell Me More*, April 1, 2010. https://www.npr.org/templates/story/story.php?storyId=125457527.

Nesteroff, Kliph. *The Comedians: Drunks, Thieves, Scoundrels and the History of American Comedy*. N.p.: München Grove Press, 2015.

Nevius, CW. "Funny Money: How Robin Williams Saved SF's Comedy Day." *San Francisco Chronicle*, September 26, 2016.

Nina G. "Comedy Time Capsule: Dena Ware." YouTube, May 22, 2020. www.youtube.com/watch?v=FU_3KoLPxd4.

Nolan, D. "Hic, Haec, Ho-Ho-Hocus." *San Francisco Examiner*, May 4, 1958.

Oakland (CA) Tribune. "Reluctant Jury Frees Funny Man." March 9, 1962.

Odess, S. "Richard Pryor, Comic, Actor, Activist." Berkeley Historical Plaque Project. Posted 2016. https://berkeleyplaques.org/e-plaque/richard-pryor/.

The Other Cafe. "NPR Interview." Accessed May 31, 2021. https://www. theothercafe.com//wp-content/uploads/2008/04/the_story_1156_ Bob_Ayres2.mp3.

Paul, Ivan. "Around Town with Ivan Paul." *San Francisco Examiner*, 1958.

Phillips, Justin. "Doc's Lab Closes Without Warning in North Beach." *San Francisco Chronicle*, February 9, 2018.

Robertson, Michelle. "On Comedy Day, Robin Williams Lives On in Meadow that Now Bears His Name." *San Francisco Chronicle*, September 17, 2018.

Sacramento Bee. "SF Comedy Competition Friday in GV." September 15, 2016.

Saito, Stephen. "Flashback—Interview: Only the Lonely: The Rice of Andy Samberg, Akiva Schaffer and Jorma Taccone." The Moveable Fest, July 24, 2012. Internet Archive. https://web.archive.org/web/20160608134533/http://moveablefest.com/moveable_fest/2012/07/lonely-island-hot-rod.html.

San Francisco Chronicle. Venue Listing. Giggle Joints. March 18, 1985.

San Francisco Comedy Competition. "Past Winners." Accessed May 31, 2021. http://sanfranciscocomedycompetition.com/about-the-competition/past-winners/.

San Francisco Examiner. Ann's 440, Lenny Bruce advertisement. June 6, 1958.

———. Ann's 440, Lenny Bruce advertisement. June 8, 1958.

———. Calendar listing for the Country Store. March 20, 1983.

———. "A Club Just for Laughs." October 9, 1978.

Saul, Scott. *Becoming Richard Pryor.* New York: HarperCollins, 2014.

Selvin, Joel. *San Francisco: The Musical History Tour: A Guide to Over 200 of the Bay Area's Most Memorable Music Sites.* San Francisco: Chronicle Books, 1996.

———. "Searchin' for the Dock of the Bay: 'Tour' Follows Footsteps of Rock and Jazz Greats." *San Francisco Chronicle*, March 19, 1996.

Shilts, R. "Gays Break Comedy Barrier." *San Francisco Examiner*, March 4, 1984.

"The Sicknicks." *Time* magazine, July 1959.

Skover, David, and Ronald Collins. *The Trials of Lenny Bruce.* Naperville, IL: Sourcebooks, 2003.

Smith, Ronald. *Goldmine Comedy Record Price Guide.* Iola, WI: Krause Publications, 1996.

Snook, Raven. "Comedy Isn't Pretty: Phyllis Diller Takes a Long Look at Her Career." *TV Guide*, December 5, 2006. https://www.tvguide.com/news/comedy-isnt-pretty-38891/.

Stein, Ruthe. "Cobb's Comedy Club Celebrates 25 Years in San Francisco." *San Francisco Chronicle*, September 3, 2007.

Stepner, C. Chuck. "'The Chain Smoking 'Priest' Who Changes His Garb in the Car." *San Francisco Examiner*, October 21, 1973.

Swan, Rachel. "From Poop to Pimp Chronicles." *East Bay Express*, November 19, 2008.

———. "T Who Has Laughs Last." *East Bay Express*, July 4, 2007.

Swartz, Tracy. "Former South Sider W. Kamau Bell Talks Chicago Episode of His CNN Docuseries." *Chicago Tribune*, April 13, 2017.

10th Annual San Francisco International Stand-Up Comedy Competition: Official Handbook. San Francisco: The Comedy Scene, 1977.

TMZ. "Eddie Griffin: Gets into Drink-Throwing Fight During His Own Show." July 15, 2012. https://www.tmz.com/2012/07/15/eddie-griffin-drink-throwing-video/.

Tyler, Robin. "Robin Tyler in ALWAYS A BRIDESMAID, NEVER A GROOM at the Diversionary 9/16-9/19." YouTube. September 8, 2010. Accessed May 31, 2021. https://www.youtube.com/watch?v=3-JsHEPs18M&t=20s.

Wahl, Kay. "She Also Cooks." *Oakland Tribune*, August 23, 1959.

Wechter, J. "Comics on The Make." *Berkeley Barb*, September 29–October 5, 1978.

Westergren, Tim. "Knock, Knock…" *Pandora*, May 3, 2011. Accessed August 18, 2021. https://blog.pandora.com/the-pandora-story/knock-knock/.

Whiting, Sam. "Dave Chappelle Joins Local Comics, City Officials Calling to 'Save the Punch Line.'" *San Francisco Chronicle*, May 21, 2019.

———. "Gay Comics Out There on National TV." *San Francisco Chronicle*, December 2, 1993.

———. "Google Comes to Aid of Punch Line, Says It Doesn't Want Its Real Estate." *San Francisco Chronicle*, May 23, 2019.

———. "Punch Line Secures Lease to Stay at SF Location, Gets Legacy Business Status." *San Francisco Chronicle*, July 22, 2019.

Wieder, Robert. "Cobb's Reopen's in Upscale Setting." *San Francisco Examiner*, September 11, 1987.

———. "Laughter Is Growing for 'Comedy Tonight.'" *San Francisco Examiner*, March 30, 1986.

———. "Racial Disharmony in Local Clubs—Rey Booker Opens Door on Concerns of Black Stand-Ups." *San Francisco Chronicle*, June 7, 1992.

———. "The Ultimate Kidder/Father of S.F. Stand-Up Gets a Tribute." *San Francisco Chronicle*, May 16, 1993.

Williams, Karen. "My Heart…San Francisco!" *San Francisco Bay Times*. Accessed May 31, 2021. http://sfbaytimes.com/my-heartsan-francisco/.

Wu, Gwendolyn. "SF's Punch Line Comedy Club to Relocate." *San Francisco Chronicle*, May 8, 2019.

YouTube. "Out There Comedy Special" Uploaded. by Moon Trent. Accessed August 13, 2021. https://www.youtube.com/watch?v=IDCgr_ucd98.

———. "Robin Williams at Dirty Trix." Uploaded by Nadsat Films, August 12, 2014. www.youtube.com/watch?v=nK0X-qqZ09Y.

Zarum, L. "Lea DeLaria on 47 'Dykes,' 'Fags,' and 'Queers.'" *Village Voice*, June 21, 2018.

Zenovich, Marina. *Robin Williams: Come Inside My Head*. HBO. 2018

Interviews and Correspondence

Able, Milt. Interview with Nina G. May 1, 2021.

Ammiano, Tom. Interview with Nina G. March 18, 2021.

Azevedo Kiehn, Rena. Correspondence with Nina G. May 16, 2021.

Bealum, Ngaio. Interview with authors. January 4, 2021.

Brown, Larry. Interview with Nina G. June 3, 2021. August 12, 2021.

Calanni, Sal. Interview with OJ Patterson. February 26, 2021.

Camia, Kevin. Interview with OJ Patterson. February 9, 2021.

Dion, Dan. Interview with OJ Patterson. March 1, 2021.

Durst, Debi. Interview with Nina G. December 29, 2020.

Edwards, Greg. Interview with OJ Patterson. February 11, 2021.

Evers, Barbi. Interview with Nina G. March 9, 2020.

Ford, Patrick. Interview with Nina G. December 12, 2020.

Fox, Jonathan. Correspondence with Nina G. July 11, 2021.

Geduldig, Lisa. Interview with authors. July 5, 2021.

Gomez, Marga. Interview with Nina G. June 11, 2020.

Hansen, Jeannene. Interview with Nina G. June 19, 2021.

Hazzard, Norman. Interview with Nina G. March 8, 2021.

Ingalls, Kymberlie. Interview with Nina G. March 9, 2021.

Lacy, Donald. Interview with authors. March 13, 2021.

Mean Dave. Correspondence with Nina G. April 20, 2021.

Munoz, Pete. Interview with OJ Patterson. June 3, 2021.

Nina G and Ethan Orloff. Interview with OJ Patterson. June 2, 2021.

Novello, Don. Interview with Nina G. June 14, 2021.

Pearl, Steven. Interview with authors. May 2, 2021.

Philips, Emo. Correspondence with Nina G. May 22, 2021.

Shydner, Ritch. Interview with Nina G. May 16, 2021. December 4, 2021.

Snow, Carrie. Interview with Nina G. June 4, 2021.

Sparks, Tony. Interview with authors. February 25, 2021.

St. Paul, Dan. Interview with Nina G. December 15, 2020.

Van Note, Mary. Interview with OJ Patterson. July 16, 2021.

Weber, Myles. Interview with Nina G.

Wonder Dave. Interview with Nina G. March 29, 2021.

Zamaria, Jeff. Interview with OJ Patterson. July 15, 2021.

ABOUT THE AUTHORS

Nina G is a stand-up comedian, author and disability advocate. She performs and gives keynote speeches at colleges, companies and conferences across the world. Nina is the author of *Stutterer Interrupted: The Comedian Who Almost Didn't Happen* and the children's book *Once Upon an Accommodation: A Book About Learning Disabilities*. She is a Bay Area native spanning five generations and resides in Oakland. Additionally, she has contributed to books, blogs and articles and is a favorite among podcasters and comedy audiences all over. For more on Nina, go to www.NinaGcomedian.com.

OJ Patterson is a writer, comedian and homebrew historian born and raised in Pittsburg, California. A "retired stand-up," he's contributed to numerous online and print publications, including his award-winning blog *Courting Comedy* and as an entertainment copywriter. OJ Patterson currently resides in the greater Los Angeles area and unofficially has the best laugh in the room.

Photo by and courtesy of Adam Pfahler.

Visit us at
www.historypress.com